AN INTRODUCTION TO

JAPANESE
CALLIGRAPHY

First published in Great Britain 2005 by

Search Press Limited
Wellwood, North Farm Road,
Tunbridge Wells, Kent TN2 3DR

Originally published in France 2003 by Groupe Fleurus, Paris
Original title *Initiation Calligraphie Japonaise*
Copyright © Groupe Fleurus, Paris 2003
Editor in Chief: Christophe Savouré
Publisher: Guillaume Pô
Artistic Directors: Thérèse Jauze, Félicie Cogan
Layout: Florence Bellot
Photography (unless otherwise stated): Bertrand Mussotte
Dummy: Claude Poirier
English translation: Sarah Buckland
Japanese consultant for the English translation: Mary Banks Murayama
English translation copyright © Search Press Limited 2005

ISBN 1 84448 057 7

If you have any difficulty in obtaining any of the equipment or materials mentioned in this book, please visit our website at www.searchpress.com. Alternatively you can write to the Publishers at the address above for a current list of stockists, including firms which operate a mail-order service.

Manufactured in France - 92653-02 - Reprinted 2007
Printed by Pollina, 85400 Luçon - n° L42371
Cover illustration:

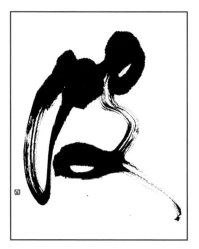

Japanese syllable **ha**
Written in the ancient style of sōgana, this shape is evocative of a 'wave', depicted by the kanji from which it originates.

Acknowledgements

Kojima Masamichi 小島 正道, Director of *Isshin-dô* 一 心 堂, for his invaluable advice and assistance;
Takagi Masanori 高 木 真 徳, for his assistance;
Ôshima Sanpô 大 嶋 三 峰, for permission to reproduce his calligraphy;
Sumiyama Nanhô 炭 山 楠峰, for permission to reproduce the calligraphy of his father, Sumiyama Nanboku 炭 山 南 木;
Masuichi Masako 増 市 昌 子 and Monsieur Masuichi Etsuji 増 市 悦 士 for permission to reproduce the calligraphy of Masuichi Tôyô 増 市 東 陽;
Marion Dumaine, for the photographs on page 74;
Madame Marie Bénédic, for the original French translation of the *i-ro-ha* song and the poem of Taneda Santôka 種 田 山 頭 火;
Françoise Blanchouin, for re-reading the original French text;
Olivier Boit, for all the precious time he devoted to correcting the original French text.

Names are given in Japanese order, i.e. family name, then first name or the name of the artist.

AN INTRODUCTION TO

JAPANESE CALLIGRAPHY

Text and calligraphy by
Yuuko Suzuki

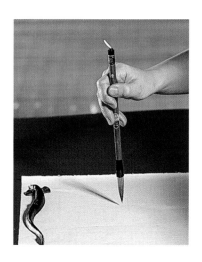

SEARCH PRESS

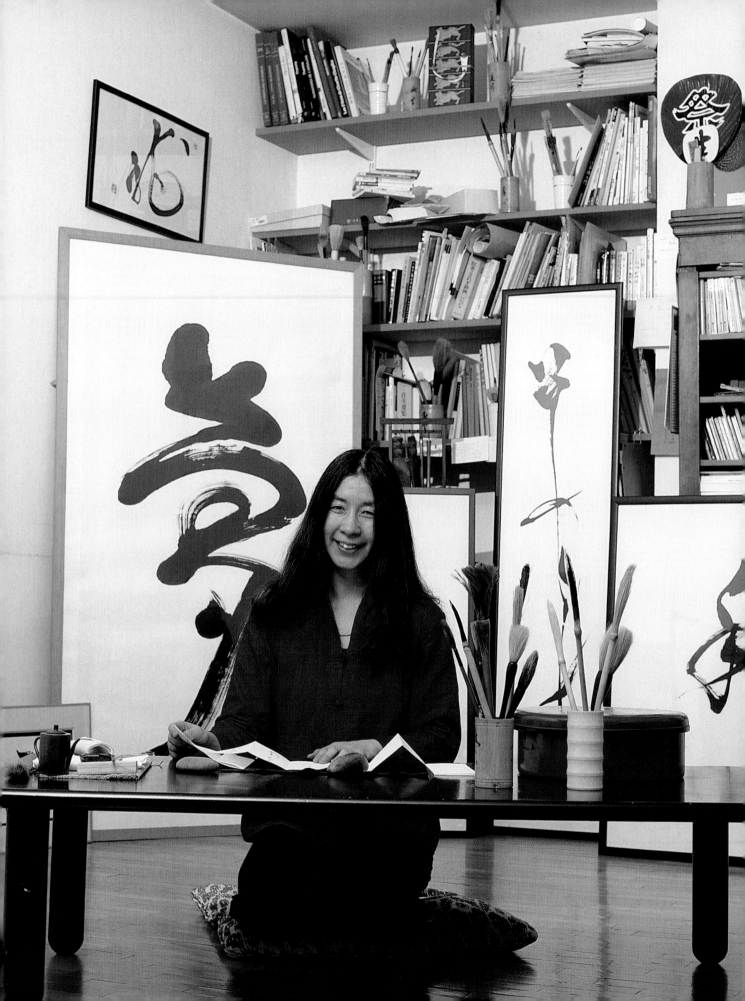

Contents

The history of Japanese calligraphy

Japanese is written using a combination of *kanji*, ideographic characters borrowed from Chinese[1]; and *kana*, purely phonetic symbols which make up two distinct syllabaries: *hiragana* (the principal syllabary) and *katakana* (used today primarily for writing foreign words and onomatopoeia). The co-existence of these systems gives the writing and calligraphy of Japanese a great richness.

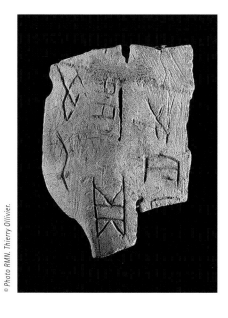

▲ *Part of a tortoise shell used as a divine tablet. Shang Dynasty (1650-1066 BC). Guimet Museum, Paris.*

The dawn of calligraphy – China

It all began in China. Although primitive signs engraved on Neolithic pottery date from nearly 6000 years ago, the first Chinese writing is thought to date from the Shang Era 商 . Engraved between the 17th to 12th centuries BC on tortoise shell or animal bones, the characters, representing oracles, show the first ideographic writing. In them it is possible to discern the origins of characters used today. 3400 characters have been identified, of which more than half have been deciphered.

From this period onwards historical events and rituals were systematically transcribed. Various writing styles evolved with the materials used (bronze, stone, fabric, and blocks), and this continued until the introduction of paper, of which the oldest examples found date from the 2nd century BC. Each period had its own master calligraphers, whose works represented the philosophy and literature of their time, and numerous Chinese writing styles followed and evolved. Today, there are essentially five styles of *kanji* 漢字 : calligraphy the 'seal' style *zhuanshu* 篆書 (*tensho* in Japanese), the ancient squared (clerical) style *lishu* 隸書 (*reisho* in Japanese), the grass (cursive) style *caoshu* 草書 (*sōsho* in Japanese), the running (semi-cursive) style *xingshu* 行書 (*gyōsho* in Japanese) and the block style *kaishu* 楷書 (*kaisho* in Japanese).

The birth of Japanese calligraphy

There was originally no indigenous written language in Japan. Chinese writing was known, but it was the introduction of Buddhism and Confucianism from China which accelerated the assimilation of Chinese characters into Japan. They became known as *kanji* 漢字 . The materials used for calligraphy were also imported into Japan, probably around the same time, from China and the kingdoms of the Korean Peninsula.

The earliest Japanese calligraphy was written directly in Chinese. In spite of their geographic proximity, the languages of China and Japan had nothing in common and this quickly led to the introduction of an intermediate language *kanbun* 漢文 or *mana* 真名 ('real written language'). Until the reforms of the Meiji Era 明治 , this written form served as the official language of administration and diplomacy, science and technology, religion (especially Buddhism), philosophy and, in fact, all theoretical thought. The oldest surviving

1. Literally 'Chinese characters'

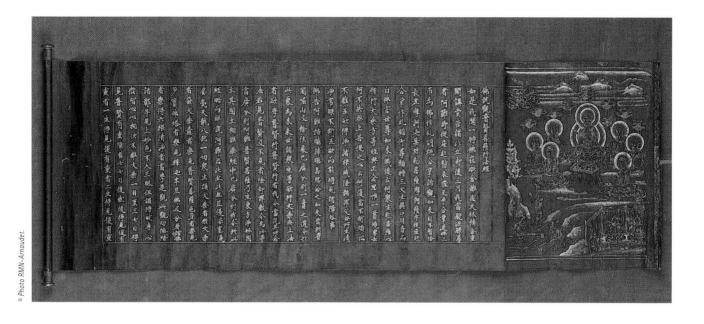

written work in Japan, the *Hokke gisho* 法華義疏, was written in this language in 614 and 615 by Prince Shōtoku Taishi 聖徳太子. It is a summary of the *Lotus Sutra*.

At the same time the Japanese used Chinese characters phonetically, disregarding the sense of the word but keeping the sounds of *kanji* as they understood them. These were purely phonetic characters called *kana* 仮名 (provisional writing). The first collection of Japanese poetry, the *Man.yō-shū* 萬葉集 or 'collection of 10,000 leaves' was written in *man.yō-gana* 萬葉仮名 around 760. These *man.yō-gana*, also called *onoko-de* 男手 ('male writing') or *ma-gana* 真仮名 (real *kana*) formed the basis of *kaisho* style calligraphy, but the letters were complicated and there were too many homonyms. Once phonetic writing was generally accepted by the population, the letters became

incorporated into *gyōsho* 行書 and *sōsho* 草書 writing styles. This *kana* is called *sō-gana* 草仮名.

From *sō-gana* 草仮名, *hentai-gana* 変体仮名 (varied *kana*), was developed by simplifying the written form. The *hentai-gana* was elegant and graceful and, like the *sō-gana*, is still occasionally used to this day, especially for old poems in *kana*. The first were called *onna-de* 女手 (female writing), because they were used by women. In the Heian Era 平安 (794-1185) women had no official functions, which allowed for the birth of a brilliant literature from the likes of Murasaki Shikibu 紫式部, Izumi Shikibu 和泉式部 and Sei Shōnagon 清少納言. *Hentai-gana* was also used by men for poetic expression.

Evolution and modernisation

Following a period of loyalty to the spirit of Chinese writing, the Heian Era, which

▲ *'Sermon on the Summit of the Vautours'*, epilogue of the Lotus Sutra. Kaisho *style* kanji. Heian Era (11th century). Guimet Museum, Paris.

7

essentially represented the birth of Japanese calligraphy, saw the introduction of some important stylistic changes. Many brilliant men had already written in *kanji* (and in *kanbun*) in spite of their in depth studies of Chinese calligraphy. The most famous of them was perhaps the monk, Kūkai 空 海, who compiled the first dictionary of *kanji*.

At the end of the 9th century, the imperial court stopped sending ambassadors to China and Japanese style flourished in all cultural domains. During this time *kana* calligraphy continued to evolve. Amongst the many major works the most famous are the variants of *Kokin waka-shū* 古 今 和 歌 集, ('collection of ancient and modern poems'). On luxury papers, died, sequinned and decorated, the grand calligraphers of the nobility distributed their works. Called *chirashi-gaki* 散 ら し 書 き ('scattered writing') this type of calligraphy is still considered by the Japanese as a refined and elegant art form.

During the 9th century the **katakana** 片 仮 名 (like the *hentai-gana*) syllabary evolved, born of a need for a system of annotation to replace the symbols in Japanese, or to indicate the particles, inflexions or suffixes necessary for their translation. Simple and angular, these characters were created by cutting out the part of a Chinese character used phonetically. The term **hiragana** 平 仮 名 appeared in the Muromachi Era 室 町 (1333-1568). The *hiragana* were born of an artistic simplification even more advanced than *hentai-gana* (*hiragana* = *hira* + *kana* = easy *kana*; katakana = *kata* + *kana* = *kana* coming from 'a part').

The arrival in power of the warriors in the Kamakura Era 鎌 倉 (1192-1338) brought a more energetic and vigorous calligraphy. Zen Buddhism 禅 of the Song 宋 dynasty (960-1178) was introduced at this time and Chinese monks settling in the archipelago brought with them a freer style. Their calligraphic work was particularly valued for the tea ceremony because *sadō* 茶 道 ('the way of tea') is based on Zen philosophy.[2]

During the Edo Era 江 戸 (1603-1867), the art of calligraphy began to be taught in temples to children of the working classes by Buddhist monks, samurai, doctors and Shinto priests. In 1890, during the Meiji Era, each of the two syllabaries (*hiragana* and *katakana*) was reduced to 46 characters and, at the same time, their form was fixed.

2. A scroll is traditionally hung on the wall of a room where the tea ceremony is performed.

南無一切如來四攝智金剛鉤並吾薩等遍虛空

空遍法界一切成辨並吾薩摩訶薩

南無一切如來善巧智金剛索並吾薩等遍虛空處

◀ *Extract from* Issai-kyo *'Three Sacred Books of Buddhism'. Calligraphy from the Muromachi Era (anonymous). Kaisho style kanji. Private collection.*

9

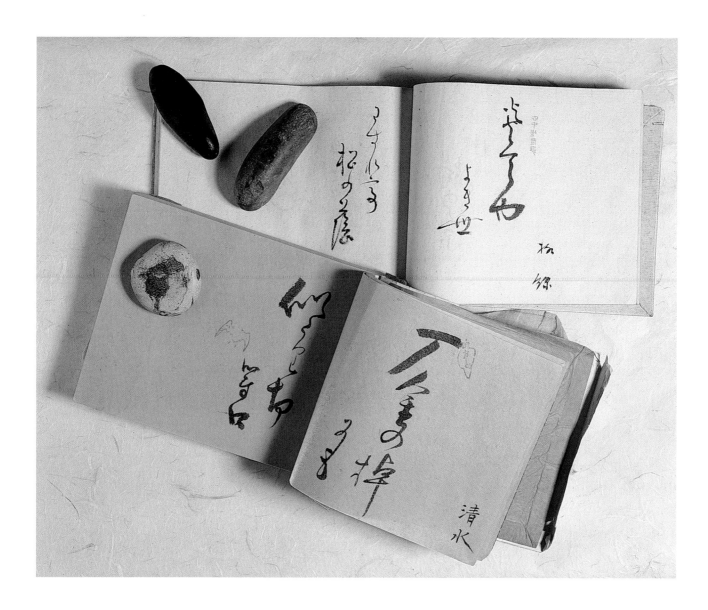

▲ Haiku book from the Meiji Era. Private collection. Traditionally amateurs of haiku met to share their poems with each other, which were then written by paint brush in a book. The master poet put his seal after each poem. Even today haiku poets write their poems with a brush.

Since then the rest of the *kana* (*sō-gana* excluded) has been called *hentai-gana*.

It would have been possible, since the birth of the *kana*, to write Japanese using only the phonetic system, but the transformation of the language and the introduction of many words of Chinese origin, meant that there were a multiplicity of homonyms making the understanding of written Japanese difficult without the visual support of the Chinese ideograms.

The Japanese language today uses both *kanji* and *kana*. *Kanji* is used to write most nouns, names, and verbs. *Hiragana* makes up the basic alphabet and is used to indicate different verb endings, adjectives and grammatical particles. *Katakana* is used to write foreign words, onomatopoeia and to replace complex *kanji*. It is therefore possible to write the same word in different ways, whether with an aesthetic aim or to clarify the meaning.

Influenced by Western culture, modern calligraphy has developed new genres and movements:

▶ the calligraphy of poems or contemporary texts mixing *kanji* and modern *kana*, or *katakana*;

▶ the calligraphy of one or several characters;

▶ abstract calligraphy (divorced from any literal meaning);

▶ seal engraving;

▶ the engraving of characters on wood, stone or other materials.

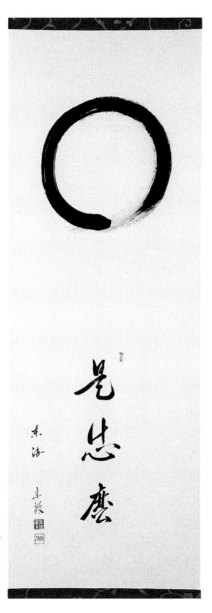

Today each branch of calligraphy, beginning with a traditional form, looks for a new horizon and a style of its own. New generations of artists try to expand their creativity, using all sorts of new materials. Tradition is not forgotten though: and it remains the source of energy for inspired thought.

▲ *Reverend Yamada, What is it? Zen calligraphy for the tea ceremony. Guimet Museum, Paris.*

The artist has used several ancient *kana* (Japanese characters) for this work. In the printed character version of the poem, under each *kana* (in its modern form) is the *kanji* (Chinese character) on which it is based (see page 14). The modern reading of the poem differs from that represented by these *kana*. The version mixed with the *kanji* is on the right.

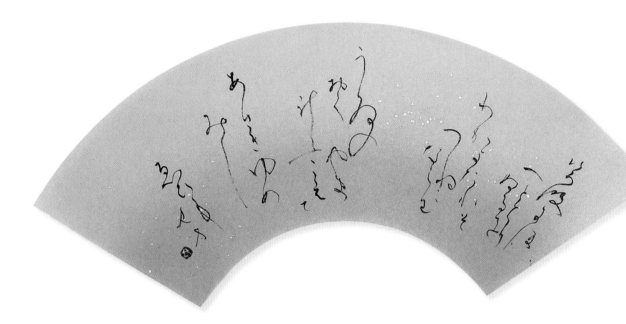

いろはにほへと
　　　波尓
ちりぬるを
わかよたれそ
つねならむ
うゐのおくやま
けふ　こえて
計
あさきゆめみし
ゑひもせす
　　　寸

色は匂へど
散りぬるを
我が世誰ぞ常ならむ
有為の奥山
今日越えて
浅き夢見じ
酔ひもせず

i-ro-ha uta いろは歌

The *i-ro-ha* song

Colours and shapes may blossom but not for long.
In this life, nobody lives forever.
Going beyond the summits of illusion.
No longer shallow dreams or ecstasy.

This famous poem by an unknown author is made up of a total of 47 *hiragana* characters (every symbol except the ん *n*). It dates from the Heian Era and originally appeared in an official document in 1079. It is a translation into Japanese of a *gatha* (in Sanscrit 'poetry in verse, hymn') of the *Nirvana Sutra* and is traditionally used to teach Japanese calligraphy.

The tables on pages 14-17 show the 47 *kana* in their modern form, together with their pronunciation, as well as the ん *n*. To the right of each *kana* is the *kanji* from which it was formed, followed by a diagram showing how the character has been transformed. The method of phonetic transcription of the adopted Japanese characters is the one used internationally.

▷ *ai* as in *haiku* 俳句 pronounced *a-i* (*life*)

▷ *e* as in *take* 竹 'bamboo', pronounced *ay* (*hay*)

▷ *u* as in *ume* 梅, 'plum', pronounced *oo* (*spoon*)

▷ *r* pronounced between l and r

▷ *s* as in *murasaki* (*moulassaki*) 紫, 'violet' (pronounced as in 'set').

▷ A lengthened vowel is shown by a line as in *Kyōto* (*kyooto*) 京都 .

Japanese texts can be written vertically (read from right to left) or horizontally as in English. In calligraphy, texts are usually written vertically as in the classic form. The work shown opposite on page 12 was written in a cursive style with a small brush of weasel hair, 0.2cm (1/16in) in diameter and with hairs 1.8cm (flin) long on Japanese paper *ryōshi* 料紙 . Many old *kana* were used.

Table of *kana* used in the *i-ro-ha* song

The characters are shown from top to bottom and from right to left. The pronunciation for this poem differs from that shown in the table. The *i-ro-ha-uta* should be read thus (without adding the final ん *n*): *iro wa nioe do / chirinuru wo / waga yo tare zo / tsune naramu / ui no okuyama / kyô koete / asaki yume mizi / ei mo sezu.*

ri	ho	i
利わり り	保保ほ ほ	以以い い
nu	**he**	**ro**
奴奴ぬ ぬ	部へ へ	呂ろろ ろ
ru	**to**	**ha**
留留る る	止とと と	波波は は
(w)o*	**chi**	**ni**
遠遠を を	知ちち ち	仁にに に

	na		re		wa
な	奈なな	れ	礼礼れ	わ	和わわ
	ra		so		ka
ら	良ふら	そ	曽そそ	か	加かか
	mu		tsu		yo
む	武むむ	つ	川つつ	よ	与与よ
	u		ne		ta
う	宇うう	ね	祢祢ね	た	太たた

こ	己ここ	や	也也や	ね	為ぬね
ko		*ya*		*(w)i**	
え	衣ええ	ま	末まま	の	乃の
e		*ma*		*no*	
て	天てて	け	計計け	お	於お
te		*ke*		*o*	
あ	安ああ	ふ	不不ふ	く	久く
a		*fu*		*ku*	

Origin / progression	Kana	Origin / progression	Kana	Origin / progression	Kana
毛 も も	も (mo)	美 美 み	み (mi)	左 さ さ	さ (sa)
世 世 せ	せ (se)	之 ゝ し	し (shi)	幾 幾 き	き (ki)
寸 寸 す	す (su)	惠 惠 ゑ	ゑ (w)e*	由 由 ゆ	ゆ (yu)
无 ゑ ん	ん (n)	比 比 ひ	ひ (hi)	女 め め	め (me)

Materials

The four treasures of calligraphy

From the earliest times, in China and the Far East, the instruments of calligraphy and painting have been treated with great reverence. Among them, the brush, the ink, the ink stone and the paper are the most important. They are often known as 'the four treasures of calligraphy'. Before embarking on a study of calligraphy, it is important to become familiar with these tools.

The brush

The shape of the brush

There are two types of brush: a brush with hairs joined together and hardened (*katame-fude* 固め筆 or *mizu-fude* 水筆) and a brush with hairs that are separated (*sabaki-fude* 捌き筆, *sanmō-hitsu* 散毛筆 or santaku-hitsu 散卓筆). The former have soft hairs at the tip, which means they are used only to the centre whereas others are used along their full length. They are of a very high quality and are used by experienced calligraphers. Before a new brush is used, the hairs must be carefully washed to remove any glue and gently dried. The protective plastic cover may be discarded. The most widely used brushes are:

▸ *ryūyō-hitsu* 柳葉筆 (brush in the form of a willow leaf). The most common type. The hairs can retain a large quantity of ink and the brush is good for writing long lines. The width of strokes can be varied easily.

▸ *jakutō-hitsu* 雀頭筆 (brush in the form of a sparrow's head). The hairs are short and the tip flexible. This type of brush is used for writing small characters with delicate and precise lines.

▸ *mensō-hitsu* 面相筆 (brush for faces). Used in traditional painting for detailed work. The hairs (usually from sable or weasel) are very thin. The diameter of their base is only 2-4mm (⅛in)with a length of 2-3cm (fl-1⁄in).

▸ *engui-hitsu* 延喜筆, *shinmaki-fude* 芯巻筆 or *makishin-fude* 巻心筆 ('brush with hairs rolled around its heart'). The hairs are very flexible and easy to turn on the paper. This type of brush is used for *sō-gana* calligraphy 草仮名.

The length and diameter of the brush hairs

Brushes are divided into five categories, according to the length and diameter of the hairs:

▸ *chō-chōhō* 超長鋒 (very long): the diameter at the base of the hairs is at least six times smaller than the longest hairs.

▸ *chōhō* 長鋒 (long): the proportion is 1:5-6.

These two categories of brush do not have a very strong base and require a certain skill. They produce long, dynamic and varied lines.

▸ *chūhō* 中鋒 (medium): the proportion is 1:3-4.

▸ *tanpō* 短鋒 (short): the proportion is 1:2-3.

Chūhō and *tanpō* brushes are recommended for beginners.

▸ *chō-tanpō* 超短鋒 (very short): the proportion is 1:0.8-2. *Jakutō-hitsu* brushes are also in this category.

For *sutra* calligraphy, *tanpō* and *chō-tanpō* brushes are used.

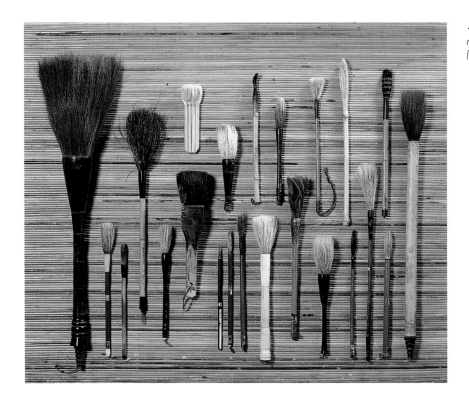

◀ A selection of Japanese and Chinese brushes made from hair (horse, goat, sable) or feathers (peacock, cockerel).

Composition of the hairs

The brush hairs are principally from animals. Brushes made from hard hair are called *gōmō* 剛毛, and those with more flexible hair, *jūmō* 柔毛. Animal coats usually contain both hard and flexible hair types. Some brushes mix the two hair types and are called *kengō* 兼毫.

The variety of brush hair is huge. Most common are the hairs of goat, horse, *tanuki* (Japanese racoon), weasel, sable, hare, squirrel, cat, stag and – more rarely– fox, monkey or buffalo. Feathers or vegetable fibres may also be used. There is even a custom of parents using the hair of new-born children to write wishes for their child's happiness. These brushes are flexible and delicate and are particularly appreciated by calligraphers.

The 'four virtues of the brush'

From the time of the Ming Era it has been said that a brush of the highest quality should have the following features:

▶ *sen* 尖 : the tuft must be pointed.

▶ *sei* 斉 : when the hairs are flattened, the ends line up. With horse hair, a more transparent tip indicates superior quality.

▶ *en* 円 : each part (the tuft, the neck, the centre and the base) can turn easily when soaked with water or ink.

▶ *ken* 健 : hairs are evenly distributed and move easily when in use.

Usually Japanese brushes contain *inochi-gué* 命毛 (life hairs): these are the 2-3 longest hairs in the middle of the tuft. Pointed and sharp, these hairs make the lines of the *kana* and the *kanji*. If these hairs are cut or damaged, the brush can no longer be used for calligraphy.

Japanese brushes have a solid base enabling the tip to draw effectively. Chinese brushes have a rounder and thicker tip. They are adapted for writing thicker characters. The brush handle is often made from bamboo, although it can be made from other woods, horn, bone or clay. Precious collections can be beautifully decorated with gold, silver, precious stones and ivory.

After each use, the brush must be washed with cold water then wiped gently and hung with the hairs downwards to dry.

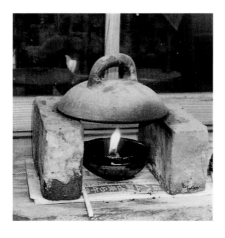

▲ *Burning vegetable oil to make soot (Nara). Photo Nicolas Feuga.*

The ink

The composition of the ink

The ink traditionally used for Japanese calligraphy is called *sumi* 固 . Made principally from soot and animal glue, it comes in a solid block which is rubbed on a stone with cold water. The 'colours' of ink are given shades of black: a discerning eye can find blue, brown, violet, red and green.

▶ *Animal glue* nikawa め

The glue helps the soot to bind and the ink to stay on the canvas. It gives the lines a brightness and clarity. In China it is made from fish glue; in Japan it usually comes from the skin of an animal such as a cow, buffalo or stag. A gelatinous substance is obtained from this when heated. It solidifies on cooling. Its transparency and lustre are signs of its quality. The substance is boiled and stirred for a long time in a leather bucket, producing a viscous liquid which is left overnight, boiled again and finally filtered. To rid it of its animal smell a perfume is added – musk, camphor or synthetic perfume.

▶ *Soot* susu 筆

Two types of soot are used in the fabrication of ink: pine soot and vegetable oil soot. Ink from vegetable oil soot, *yuen-boku* 水 筆 , is thick and a deep black, appearing almost brown when diluted, with violet, red and sky blue hues. Small and equally formed particles allow the block to slide easily on the stone. It is derived from rapeseed (*colza*), sesame and camellia.

Ink from pine soot, *shōen-boku* き 筆 散 , is less thick, has a grey-blue tinge and is matt. Brush strokes have a magnificent brightness. The nature of the ink, with its irregular particles, gives painters and calligraphers a variety of shades of black.

Nowadays pure pine soot is rare because there is too much work involved in its preparation. Instead it is often mixed with chemicals, especially anthracite, which gives almost identical results.

There are also many industrial inks, although their lines lack finesse. The added colorants are not waterproof, do not keep well and are difficult to mount. These types of product are looked down upon by calligraphers and it is wise to consult an expert.

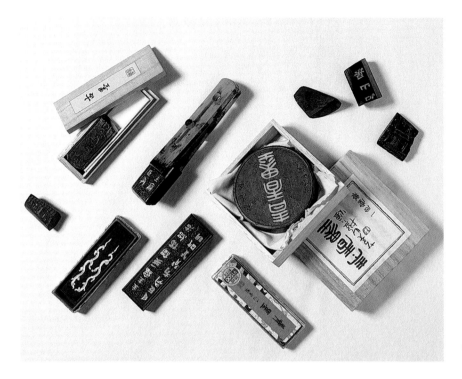

◀ *A selection of Japanese inks. For small pieces bamboo tongs are used.*

The life of ink

Traditional ink is not inert but, as an organic material continues to change after it is made. Specialist suppliers keep ink for several years before putting it on sale. The older the ink, the more subtle its hues.

The 'older' inks, *ko-boku* 古古 , are 50-60 years old. At 100 years they become a collector's item. Once on paper the ink becomes fixed. Its nuances and impact defy time. Chinese ink that has been aged like this is more dense and softer than Japanese ink, due to higher proportions of glue, and when used on Chinese paper produces a soft tone. Japanese ink is better for the lengthening of lines and is often used for *kana* small brush calligraphy on Japanese paper, *ganpi* 雁新 . Various Japanese inks are available and it is possible to achieve the delicate strokes required for writing *kanji*. Each calligrapher must choose the ink best suited to his work but for the best results it is also necessary to use a good quality ink block.

After use, the block should be wiped, wrapped in paper and kept in its original box, away from sunlight and humidity. If the block came in a plastic bag (not a sign of good quality) do not put it back inside. The stone on which the ink will be prepared must be clean and dry. Never put the ink block on a wet stone as it could stick to it, breaking or damaging the stone.

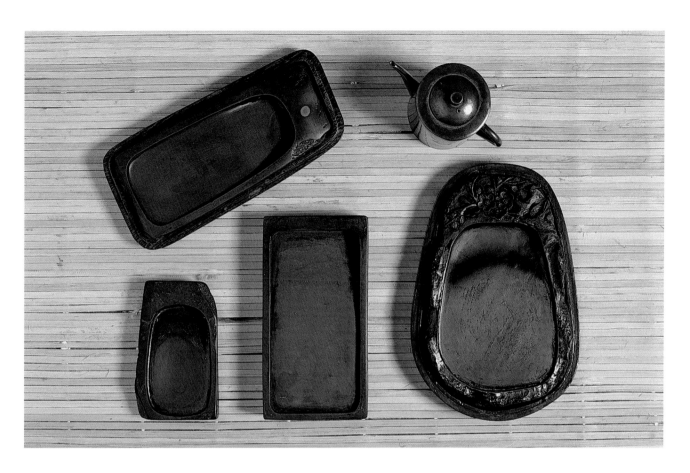

▲ *A selection of ink stones. The stone shown bottom left is Japanese, the others are Chinese. The stone at the top has an 'eye' – a fossilised insect adds considerable value.*

The ink stone

An ink stone is used for the preparation of liquid ink, by rubbing the ink block on it with some water. In Japanese, it is called *suzuri* 硯 . Among the 'four treasures of calligraphy' the stone has the longest life and is also the most difficult to choose.

There are two types of stone used: underwater, like the renowned Chinese rock *duanxi* 端渓 (*tankei* in Japanese) and sedimentary rocks, such as *shexian* 歙県 (*kyūjū* 歙州 in Japanese). An ink stone of good quality is usually black with hues of red, violet or green, and is moulded to a rectangular or oval shape. The stones have a flat part, the 'hill' (*oka* 丘 or 岡),and a hollow part, the 'sea' (*umi* 海), which holds the liquid ink.

The quality of the ink stone determines the shades that can be made on paper. A good stone, although smooth, does not wear away easily. Ink blocks of high quality will not reveal their full beauty unless rubbed on a stone of equal quality, although not all stones are good with all inks whatever their quality.

Beginners can use simple stones that do not require much work but should progress to better quality stones. Plastics stones are designed exclusively for chemical liquid ink.

The best stones have always come from China. Some mines still exist but stones of over a hundred years old (*ko-ken* 古硯) are more sought after than modern stones (*shin-ken* 新硯). Some regions in Japan produced stones of good quality but the mines have now been exhausted.

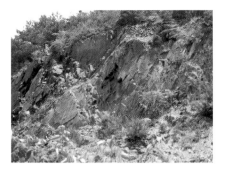

▲ *Stone mine in the Ogatsu region (Miyagi prefecture).*

▲ *Good stones are still hand engraved today. Photographs are reproduced courtesy of the Sawamura Seiken Society.*

The different types of stone

There are many varieties of Chinese stone, each with its own distinctive quality; the most famous being the *tankei* and the *kyūjū*.

Since the time of the Song dynasty, the *tankei* have been considered the best stones. They produce an ink of incomparable quality. Some are green, but they frequently display a violet hue. Their surface is smooth with a hard texture. The *tankei* stone can be used for hundreds of years.

Kyūjū stones were discovered at the beginning of the 8th century; a century after the *tankei*. From solidified glaciers, they are dark black with blue tints and sometimes gold and silver reflections due to the presence of copper sulphate. As they have a natural sparkle they are rarely decorated.

Since the old mines are exhausted, there are imitations now available on the market, but neither the new, *tankei* (*shin-tankei* 新端渓), nor the *ramon* 羅紋 of today can compare to the quality of the stones produced during the Ming and Qing Eras.

The value of Japanese ink stones cannot compare to that of the Chinese stones. Like China, the best Japanese mines are nearly all exhausted. Particularly recommended are the *akama-ishi* 赤間石, *taka-shima-ishi* 高島石, *genshō-seki* 玄晶石 or *ogatsu-suzuri* 雄勝硯, whose reputations stem from the Edo Era, and the *amabata-ken* 雨畑硯, *sōryū-ken* 蒼龍硯 or *nakamura-suzuri* 中村硯 and *ryūkei-ken* 龍渓硯, which are more recent. Although the *amabata* have the best reputation, 85% of the market is taken up by the *genshō-seki*.

Choosing a stone

It is nearly impossible to visually judge the texture of a stone. With experience it is possible to gauge its quality by sliding a finger on its 'hill' but it is not possible to know if it will survive heavy usage. It is said that rubbing the ink block should feel 'like wax thrown onto a hot plate'. With time, a good quality stone should humidify and soften. It is said that the water the stone conserves will never freeze.

Old or new, an ink stone does not like to dry out. It is important to dampen it regularly, and wash it with care. There are special sharpening stones to reshape the 'hill', but this is recommended only for stones of the highest quality.

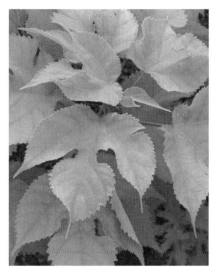
▲ Kōzo *leaves*.

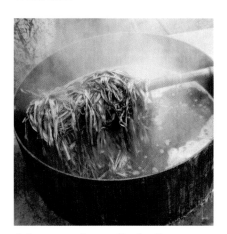
▲ *Paper preparation – cooking the skins.*

▲ *Manual threshing of the fibres. Photographs produced courtesy of the Awagami Factory Society.*

The paper

Chinese paper

Paper was used in China long before in Japan. The introduction of Buddhism encouraged the production of paper used for writing down the sutras translated from Sanskrit. From the Han Era until that of the Six Dynasties, the most widely used paper was made from hemp. During the Tang dynasty, bamboo, blackberry bush and *kōzo* 楮, a shrub of the mulberry family, were also used. In the Era of the Northern Song, paper production grew due to the progress of printing. The provinces of Sichuan sheng 四川省 and Fujian sheng 福建省 were the two biggest production regions. The latter still produces *mao bian* 毛边 (*mōhen* in Japanese) which is slightly yellow and is often used for exercise books. Over the centuries the creation of new types of paper contributed to the development of Chinese calligraphy and painting.

Today, the most widely used traditional paper is *sen-shi* 宣紙 (*xuan zhi* in Chinese). Also called *gasen-shi* 画仙紙, it is produced from the bark of the spindle tree or elm and straw. Although thin, the paper is very absorbent and is ideal for experimenting with ink. This requires some skill. The paper comes in several types, notably *tan-sen* 单笺 or 单宣 (paper of only one layer) and *nisō-shi* 二双紙 or 二層紙 (paper of two layers).

Japanese paper

The introduction of paper to Japan dates from around the 5th century. Its production developed along with the spread of Buddhism and it became widely used by the 7th century, when important reforms of state required the use of official documents. During the 8th century, a thinner and stronger paper was introduced using a method called *nagashi-zuki* 流し漉き 'chopping method' which adds a viscous agent from the roots of the *tororo-aoi* 黄葵, the *neri* ねり. Thus the traditional Japanese paper *washi* 和紙 was born.

Paper was not used only for writing. It was used to make shutters, lanterns, umbrellas, clothes and even futons. It is still used today to cover sliding doors and windows which have wooden frames.

The three plants used principally in the production of *washi* are *kōzo* 楮, *ganpi* 雁皮 and *mitsumata* 三椏. It is nowadays used mainly for traditional painting or *ma-shi* 麻紙, and an imitation of the Chinese paper *wa-gasen* 和画仙.

Choosing paper

Paper made exclusively from paper paste, such as those produced mechanically with traditional materials, do not do justice to the beauty of inks and are not recommended, even for beginners. Generally, Japanese calligraphers recommend:

▶ For writing *kanji*: an absorbent and slightly coarse paper. Usually traditional Chinese papers, *wa-gasen* Japanese paper and those made from *kōzo* are suitable.

▶ For writing *kana*: a smooth and less absorbent paper because the strokes must be precise. *Ganpi* and *mitsumata* papers are suited to this type of calligraphy.

There are also specialist papers called *kakō-shi* 加工紙 (literally 'transformed paper'). These luxury papers are enriched with powders, straw and dyes.

Today every calligrapher can choose his materials without bowing to tradition: *kana* calligraphy using a thick brush on a wide canvas, is popular. Modern calligraphers sometimes write small *kana* on Chinese papers or on the Japanese *wa-gasen* papers. This allows the quantity of ink to be varied in the strokes for a more expressive calligraphy – this style differs from ancient times. For beginners, Chinese exercise paper *mōhen-shi* 毛辺紙 is particularly recommended.

Chinese and Japanese papers come in packs of 50 reams of 20 sheets each. It is said that it is necessary to 'allow the paper to lie' which means keeping it for several years before use. The humidity in it diminishes and the nuances of the ink are heightened. This is not the case for *kōzo* paper, which can be kept for only one or two years: any more and the fibres tighten resulting in poor ink penetration.

It is important to protect paper from humidity and sunlight. Where paper is to be kept for a long time, moth proofing is recommended. If white marks appear in the stroke of the brush it is because the paper has 'caught a cold' – its quality has altered.

Other materials and preparation

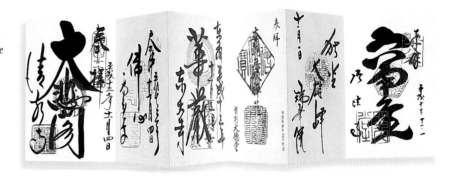

▶ *When visiting a temple, the monk (Buddhist) or priest (Shinto) writes the name of the temple/shrine and stamps his seal on a piece of calligraphy.*

The seal

The importance of the seal in the civilisation of the Far East is huge. The art of seal engraving, or *tenkoku* 篆刻 is appreciated as a branch of calligraphy.

The word *rakkan* 落款 , an abbreviation of *rakusei-kanshi* 落成款識 , means 'engraved signature certifying the completion of a work'. In a corner of the sheet (often bottom left, because the vertical text is read from left to right), the calligrapher affixes family name, first name, artist's name, the name of the author of the original text, the date of the work, and one or several seals. In a more simple style, it is possible to put only the first name or artist's name, along with the seal – sometimes even only the seal is used.

The placing of the seal is an important act for the calligrapher; his artistic sense is called upon. The size and the position of the stamp must be in harmony with the rest of the calligraphy. Customarily the seal of name and first name is put above the artist's

name. The first is usually engraved in *hakubun* 白文 ('white characters') or in *inkoku* 陰刻 ('negative engraving'), and the second in *shubun* 朱文 ('red characters') or in *yōkoku* 陽刻 ('positive engraving'). It is also possible to put the seal at the beginning of the calligraphied text, often at top or bottom right of the work.

In Japan, the bond between the master calligrapher and his disciples is very strong. The master gives his most advanced pupils the Chinese characters that will make up their artist's name. Often, one of these characters will be for all his pupils, (sometimes even from the master's own name). It is also possible for an artist to

choose a name and to use seals engraved in various styles, with characters selected according to one's own personal values. In order to find the form of the character one wishes to be engraved, there are dictionaries of Chinese characters in ancient squared style.

Engraving stones come from China. The best have a fine and even texture. They can be bought from specialist suppliers along with specially adapted chisels for different sizes and styles of engraving. To engrave the seal, a cinnabar paste is used which is a mixture of mercury, sulphur, castor oil and a vegetable-based binding agent. Once in powder form the mercury is no longer

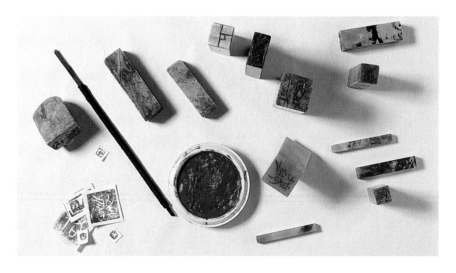

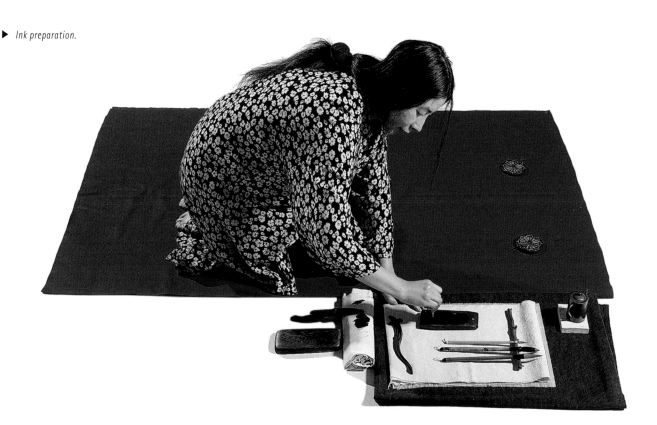

harmful. A cinnabar paste of high quality is heavy and has a deep lustre. It is much more expensive than the chemical cinnabar paste that is widely available.

Ink preparation

Take the stone from its box and put it on a towel. Pour a little pure water on to the 'hill' using a small jug. For a better quality ink use mineral or spring water. Hold the ink block upright or at a slight angle. Rub it on the 'hill' using the full surface area in a circular movement making the shape of the *no* の character.

Keep rubbing gently and slowly to thicken the ink and then pour it into the 'sea' of the ink stone. If clear water is visible then put some back on the 'hill'. Continue this until you have a homogeneous ink by adding water. If it is kept at an angle, turn the ink block so the edges are in a V shape. If it is kept upright

the rubbed side should be level. Initially it should take 15 minutes to get a good ink, but a better quality ink will take longer to obtain. It is important that this work be performed in peace and quiet. It is a precious time away from the rush of daily life.

The quality of the ink is best after an hour of preparation; it alters after a few hours. The block must be dried after use and left on a small stand before being put away in its box.

Other tools

In addition to the four calligraphy 'treasures', a jug, a stand for the ink block and the brushes, one or more paper weights and a water vessel are the other indispensable tools of calligraphy. The seals and the cinnabar paste are added at a more advanced level.

Do not forget to cover the floor or table with a double thickness of felt. This protects the surface and allows the brush to slide smoothly over the paper.

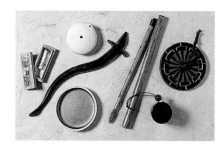

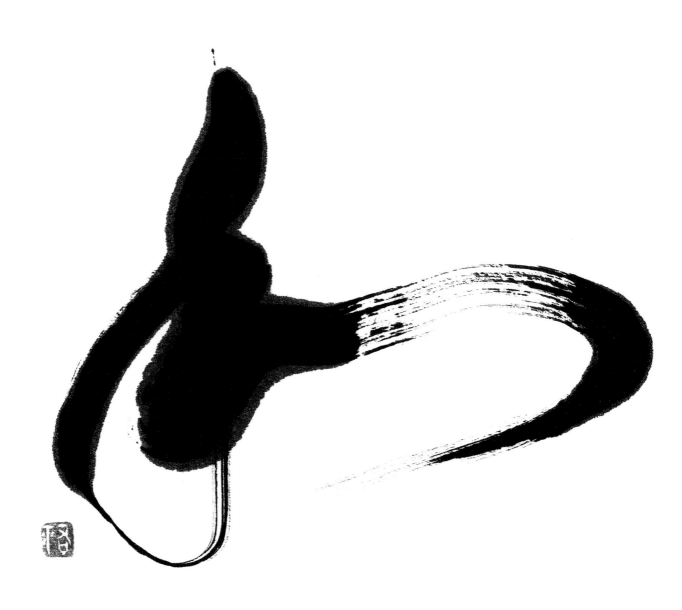

▲ *Japanese syllable wa.*
Keeping in the ancient style of sō-gana, this shape
can call to mind 'harmony' or 'peace' from the
original kanji.

Thick brush calligraphy

Preparation

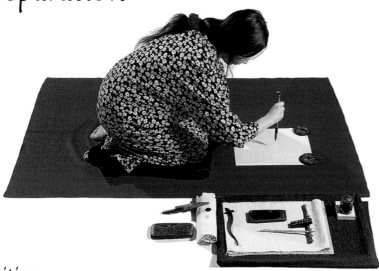

Position

Calligraphy is done with the whole body and therefore requires the correct position to attain enough freedom of movement. It is important to be flexible, relaxed and serene. The materials should be near to the hand that does the calligraphy, the paper in front. The four positions described below may be adopted for writing with a thick brush.

On the floor

Practising calligraphy on the floor allows for flexibility and enables large movements to be made. Depending on the size of the paper and the width of the strokes there are three different methods: kneeling Japanese style, one knee lifted or semi-standing. The body is leaning forward. In the first two cases, the hand that is not doing calligraphy is placed on a corner at the bottom of the

paper to support the body; this is part of the calligraphy process. The arm carrying the brush does not rest next to the body. When sitting Japanese style, the weight of the body should not be on the feet but on the lower abdomen and thighs.

On a low table

The table should be at the level of the lower abdomen or below. Sit on a cushion, with a straight back but leaning slightly forward, and leave a space about the size of a fist between the body and the table edge. The calligraphy arm should remain parallel with the sheet of paper, the other hand on the bottom left of the paper (or right for left handed people). This stabilises the body and makes the strokes even.

Standing at a western style table

Stand with legs apart, in a stable position. The upper body should lean slightly forward. The calligraphy arm must be relaxed, the other at the bottom left of the paper (right for left handed people). This position is used more in China than in Japan and it allows for easy manoeuvring of the brush.

Sitting on a chair

This position is often used in Japan, but the table height is not always ideal. It should not be above stomach level, so a cushion on the chair is sometimes useful. Feet should be flat on the floor, parallel and slightly apart. Do not cross or stretch the legs, or sit back in the chair. The back should be straight, leaning slightly forward. Leave a space the size of a fist between the body and the table edge. Arms and hands are placed as for the low table.

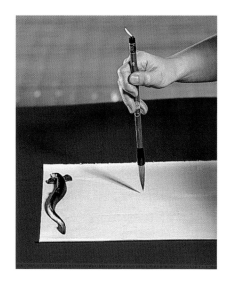

◀ *The most stable way of holding the brush is the Chinese method.*

Holding the brush

It is very important to hold the brush correctly. Ideally the brush should not be felt, but should become part of the body.

Hold the brush at the top of the handle, perpendicular to the sheet of paper. Hold it lightly keeping the hand relaxed. Put the thumb horizontally onto the inner side of the handle. Fold the index finger and the middle finger around the outer side, and the third finger and the little finger on the interior side

against the palm of the hand. This Chinese style holds the brush well and allows good freedom of movement.

Another method is to hold the thick brush with only the index finger on the exterior side of the handle. This is good for small movements and is widely used in Japan. It does not however allow for a stable grip hold and is not good for writing dramatic and bold lines.

Parts of the brush

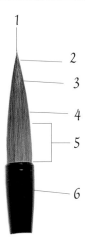

1. 命毛 *inonchi-ge* (lit. 'hairs of life') tip
2. 鋒先 *hokosaki* (lit. 'point of iron') upper core
3. 喉 *nodo* (lit. 'throat') neck
4. 腹 *hara* (lit. 'belly') centre
5. 腰 *koshi* (lit. 'hip') base
6. 軸 *jiku* shaft

Writing *kana*

Basic movements

To master the calligraphy of Japanese characters properly one needs to know some basic movements and to have some Chinese exercise paper *mōben* or Japanese *hanshi* 半紙, approx. 24.5 x 33cm (9⅝ x 13in), a brush of horse or goat's hair, 1cm (⅜in) in diameter and 4.8cm (1⅞in) long, and ink prepared on an ink stone.

Before starting, it helps to try and do some strokes by hand, or to repeat the movement mentally before picking up the brush. Once the stroke has begun, one should no longer think about it. Only a quiet mind is able to do the right strokes and to make them flow. This sequence is the most important element of calligraphy and is called *kimyaku* 気脈, sequence of '*ki*' – the *ki* 気 represents breath, energy, the soul, the spirit and humour all at the same time. *Kimyaku* means that the characters form a living totality. It is important to have this totality and not to stop characters in mid-flow and to try to recapture it, as this would destroy the harmony.

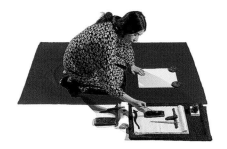

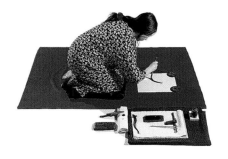

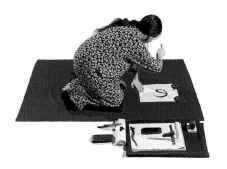

Hold the brush as indicated on page 30. The hand, arm and body should be flexible. The whole body participates in each line of the characters. Soak the brush in the ink and drain or wipe it. The ink should remain in the belly of the tuft, too much liquid in the edges will only make the strokes 'dribble'. The drawing of a character does not end when the brush leaves the paper.

No stroke is easy. Even the most elementary strokes need a beginning, middle and end, each distinct and bringing with it the memory of its Chinese character of origin. The most frequent beginners' error is that the hairs of the brush separate during the drawing of a character. Beginners tend not to press hard enough on the brush. They need to learn to apply pressure little by little, without crushing the hairs.

▲ *The calligraphy of* の *no.*

い *i*

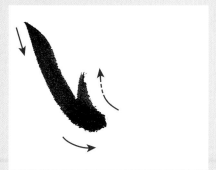

1 Place the brush gently onto the paper and slide it immediately downwards with a slight curve.

2 At the bottom stop the movement for a second whilst maintaining the pressure, then release the energy, before going on to the next part of the character.

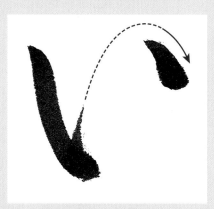

3 Curve the line and increase the pressure, then wait 2 seconds before carefully lifting the brush.

う *u*

1 Slide the brush quickly while slightly curving the line and increasing the pressure, then wait one second before releasing the energy which will be regained for the second stroke.

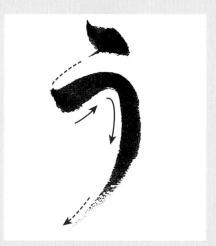

2 Place the brush with some pressure, then slide it upwards to the right and turn the brush to draw the stroke downwards: the end of the brush hairs should keep turning to make the rounded angle. Move the brush slightly to the left at the end of the stroke and lift the brush without increasing speed.

け *ke*

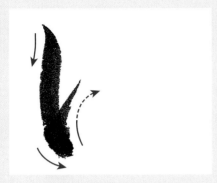

1 Place the brush gently and immediately, move it downwards curving slightly. Stop for one second before releasing the energy.

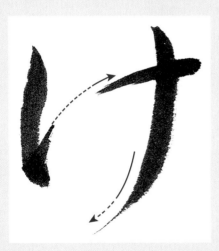

2 Stop one second at the right side, lift the brush and put it carefully on the first part of the last stroke. Slide the brush down and finish as in the last movement of う *u*.

こ *ko*

1 Slide the brush whilst increasing the pressure and curving the stroke. Stop one second at the right side and release the energy which will be regained for the second stroke.

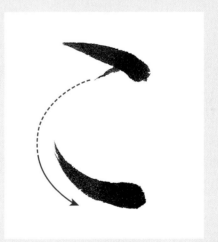

2 Slide the brush to the right whilst slowly increasing the pressure, then stop for 2 seconds at the end before lifting the brush towards the heart.

Basic shape

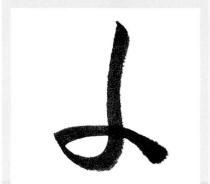

This shape is used for several *kana*, especially the two on this page.

1 Place the brush and draw downwards with a delicate curve. Slow down when you get to point (a), lift the brush until only the ends of the brush hairs touch the paper. Slowly turn the hairs and draw the first part of the oval.

2 Wait half a second at point (b), again turn the brush hairs to place them in the direction of the movement and finish the oval.

3 Wait 2 seconds at the end before lifting the brush slowly.

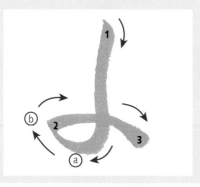

よ *yo*

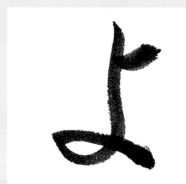

1 Draw quickly, slanting the first stroke from left to right and increasing the pressure. Wait one second before lifting the brush.

2 Draw the basic shape.

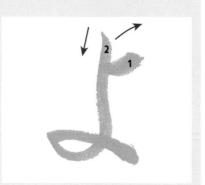

は *ha*

1 Place the brush gently and slide it downwards whilst slightly curving the stroke. Wait one second at the bottom before releasing the energy.

2 Wait one second at the right side before lifting the brush, then place it lightly on the first point of the basic shape.

3 Draw the basic shape.

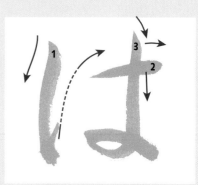

の *no*

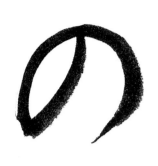

It is said this character represents the essence of Japanese calligraphy; several *kana* are based on the same type of circular movement. Avoid drawing a simple circle. The end of the character is followed by a big movement of the arms and body.

1 Place the brush gently and quickly draw the first stroke whilst increasing the pressure and drawing a curve.

2 Slow down at point (a), lift the brush to its point and turn the brush hairs in the direction of the movement.

3 At point (b) turn the brush delicately on its point, the make a big circular movement. Finish by lifting the brush quickly.

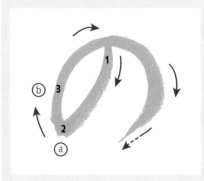

あ *a*

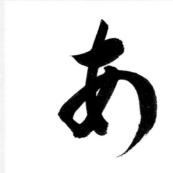

1 Draw the first stroke quickly, slanting slightly. Stop at the right side for 1 second.

2 Place the brush gently to draw the second stroke in a small arc. At the bottom wait 1 second, lift the brush and start the third stroke.

3 Draw the slanted stroke quickly and slightly rounded whilst increasing the pressure. Slow down at (a) and lift the brush to turn the point of the tuft. Slow down at (b) and again turn the brush on the point of the tuft to make a circular movement.

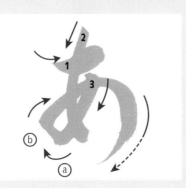

お *o*

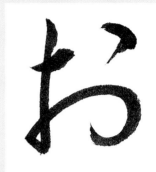

1 Draw the first slanted stroke quickly whilst gradually increasing the pressure. Wait 1 second on the right side before lifting the brush. Then put the tuft on the first point of the second stroke.

2 At point (a), slow down to turn the brush on its point. Slow at (b) and turn the brush again. At bottom right allow the energy to go towards the top.

3 The last small stroke, resembling a drop of water, must be done in 3 movements. Wait one second at the end before releasing the energy in big movement.

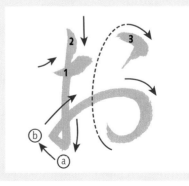

Some words

It is possible to write Japanese words using only *kana*. So that they remain words, they must be drawn as though they were done with one stroke, without reloading with ink.

ふね *fune*, boat

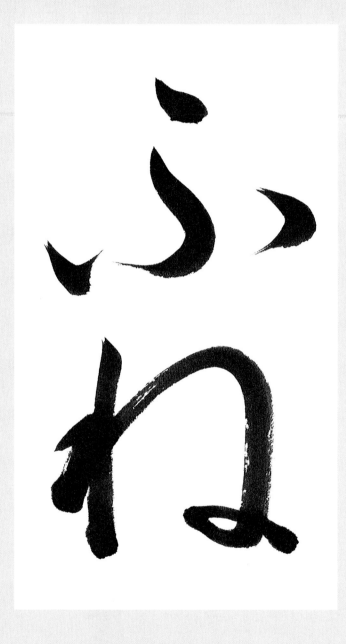

ふ *fu*

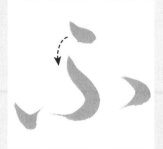

For the first stroke, take the first movement of う *u* (page 32), then follow it with the other strokes as smoothly as possible.

ね *ne*

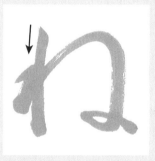

Place the brush gently and draw downwards quickly towards the bottom. Stop the brush for half a second. The next stage is complicated: it involves two changes of direction in one go, whilst rotating the brush hairs a half turn. Stop for half a second after each rotation. The final movement is initially fast, then slows down at the rounded angle at top right.

あかり *akari,* light, lamp あ *a*

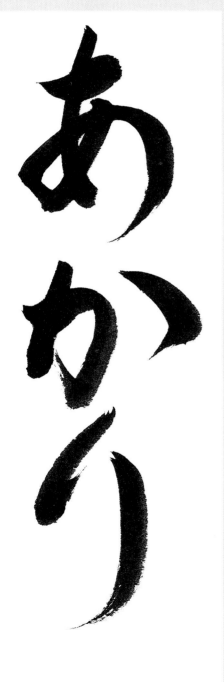

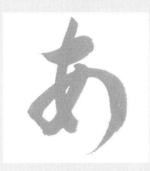

See page 35.

か *ka*

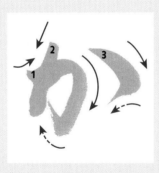

1 When the rounded angle is reached, slow down whilst turning the point of the brush.

2 At the end of the first stroke, wait one second before releasing the energy which will be regained for the second stroke.

3 The last stroke must be drawn in three movements as in the last stroke of お *o,* but bigger.

り *ri*

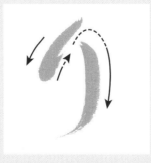

The first stroke is rounded to the left. For the last stroke follow as for う *u* (page 32) and け *ke* (page 33).

Combining *kana* and *kanji*

It has been possible since the birth of *kana* to write Japanese phonetically, but the transformation of the language, with the introduction of many words of Chinese origin or words created from a Chinese model, has meant there are many homonyms which make comprehension difficult without the visual support of a Chinese character.

The use of *kanji* makes reading a text quicker, because it allows immediate comprehension of the meaning of words. It is used to write most nouns – even Japanese ones – names, verb stems or qualitatives. It is easy to use *kana* or different *kanji* to write the same word whether this be in a graphic sense or to reconfirm its meaning. This process is used particularly in poetry in the calligraphy of *kana*.

The basic elements of *kanji*

一 *ichi*, 'one'

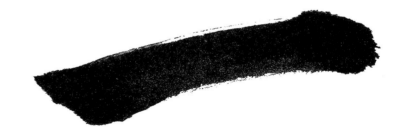

A single horizontal stroke, this *kanji* is an essential element of Chinese characters, for both its form and its significance. Hold the brush handle straight. Before touching the paper, begin by a movement from right to left in order to concentrate all your energy. Put the brush hairs at an angle of 45° for two seconds then quickly draw a lightly curved line without slanting the brush. At the end wait two seconds whilst concentrating all your energy again. Lift the brush with a light diagonal movement until only the ends of the brush hairs touch the paper. Lift the brush and return it towards the body. It is only at this moment that the character is complete.

鉄柱 *techū*, 'iron pillar'　　　撥ね *hane*, 'jump'

Begin with a movement from bottom to top before placing the brush at 45°. Turn it to make the brush hairs vertical. Draw downwards leaning on the left side of the stroke. Wait one second and lift slightly so the brush hairs return to their place. Lift slowly towards the centre of the stroke before bringing it back to you.

Draw the vertical stroke 鉄柱 *techū*. Wait one second and roughly turn the brush diagonally a few millimetres to the left. Release the energy in a slightly curved line at 45° whilst lifting the brush and rolling the brush hairs to arrange them round the tip; the arm will continue the movement in the air, letting the energy go.

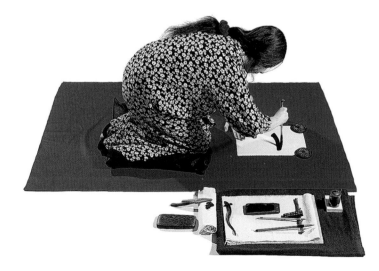

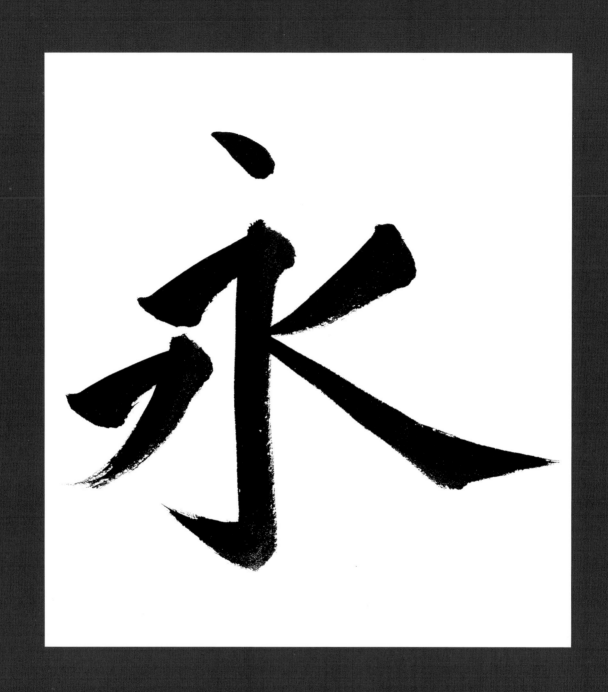

The character 'eternity'

Since ancient times the Chinese character 永 *ei* (long lasting, eternal) has been used to teach the 8 basic *kanji* strokes: 側 *soku*, 勒 *roku*, 努 *do*, 趯 *teki*, 策 *saku*, 掠 *ryaku*, 啄 *taku*, 磔 *taku*. The pronunciation of these strokes is Japanese, an approximate transcription of the original Chinese sounds.

1 側 *soku*, 'slope, inclination'
Usually called 点 *ten* (point, small line) in Japan, *soku* is the basis of all marks in the form of a drop of water. It is made up of three movements. Its name comes from the fact that the end of the brush hairs should always stay on the right side and the line is always drawn at an angle.

2 勒 *roku*, 'horizontal line'
Usually called 横画 *yoko-kaku*, 'horizontal line' in Japan.

3 努 *do*, 'strive, straight, vertical line'
In Japan known as *techū* or, more commonally, 縦画 *tate-kaku*, 'vertical line'.

4 趯 *teki*, 'jump, leap'
Usually called 撥ね *hane*, ('jump') in Japan.

5 策 *saku*, 'whip'
A line to draw with a lot of energy as soon as the brush is placed. Quickly rise to the right.

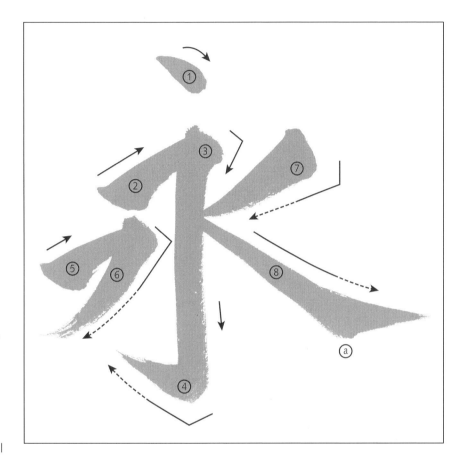

6 掠 *ryaku*, 'skim, shave, rip, strip'
Usually called *hidari-harai* 左払い, meaning 'sweeping to the left' in Japan. Push the brush as though sweeping, without gaining speed, but without hesitation. The energy leaves progressively and the brush hairs join together at the end of the movement. Continue the circular movement even after the brush leaves the paper.

7 啄 *taku*, 'peck'
Draw quickly and with energy.

8 磔 *taku*, 'rip'
Usually called *migi-harai* 右払い, 'sweeping to the right' in Japan. Regain the energy released at the end of the previous stroke, place the end of the brush and increase the pressure whilst drawing downwards. At point (a) wait one second and 'sweep' to the right whilst releasing the energy.

41

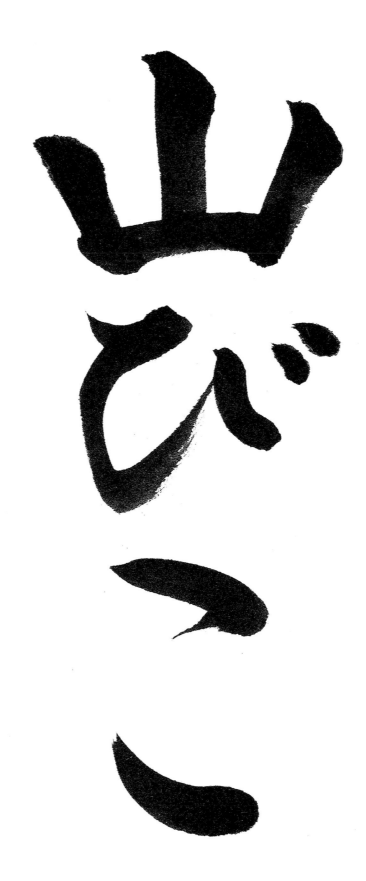

A word

山びこ *yamabiko,*
'echo, God of the mountain'

The word is made up of 山 *yama* ('mountain')
and the *kana* words び *bi* and こ *ko*.

山 *yama*

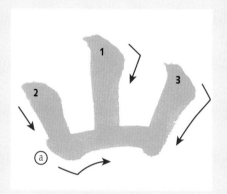

1 The first vertical stroke is like 鉄柱
techû (page 39), but at the end, lift the
brush slightly.

2 Holding the brush handle straight, place
the brush, turn it to the right so that the
brush hairs are vertical and move
downwards to (a). Lift the brush so that
only the tip of the hairs touch the paper
then, at an angle of 45° do the horizontal
line of 一 *ichi* (page 38).

3 At the end of the third movement wait
one second then lift the brush onto its
point and then return along the left side of
the line.

び *bi*

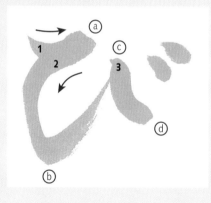

1 Place the brush and draw the curved line
and return to the right. At point (a) come to
a complete stop and turn the brush to the
right and wait half a second.

2 Draw the curved line from (a) to (b) lifting
the brush and keeping the tip of the hairs
to the left. Slow at (b) and go to (c) whilst
releasing the energy: do not press too
hard so that the brush hairs stay together at
the tip.

3 Regaining the released energy, put the
brush at (c) and finish the curved line. Wait
two seconds at (d) and add the last two
small lines to resemble drops of water (from
left to right) to turn the *hi* to *bi*.

こ *ko*

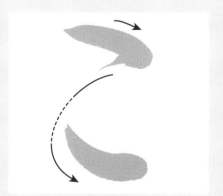

See page 33.

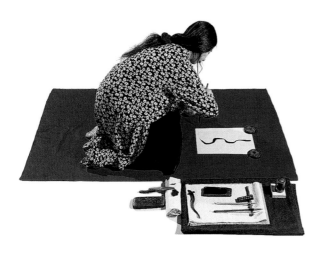

Cursive *kana* writing (renmen-tai)

As we have already seen, Japanese characters come from a simplification of the Chinese characters in the *sōsho* 草書 ('cursive script') style. This simplification pleases the Japanese aesthetic style and is accomplished naturally in the linking of the characters. The art of linked slender brush calligraphy is still considered to be the soul of Japanese calligraphy.

Modern day apprenticeship methods teach contemporary Japanese characters initially using a thick brush. Next is the linked style *renmen-tai* 連綿体, usually starting with a thick brush before moving on to the traditional calligraphy of cursive *kana* using a slender brush.

In contemporary Japanese calligraphy it is usual to use a thick brush to write *kana* on various sizes of paper. Solid lines can be written whilst playing with the many nuances of the ink.

Basic movements

The three basic movements allow an understanding of the changes in direction and pressure of the brush that take place in a long movement. Mastering these moves enriches the strokes and brings the calligraphy alive. The handle of the brush must be held straight even when writing curved lines.

Serpentine lines

1 Put the brush on (a) leaning to the right side and move downwards whilst curving to the right.
2 At (b) gradually lift the brush without slowing down. Lean towards the left of the line and then to the right at point (c) and increase the pressure. Continue.
3 Release the energy at the end to the left.

Winding line with curves and bends

1 Put the brush at point (a) leaning to the left. Lift it gradually. Draw a curve to point (b).
2 Wait half a second. Draw the fold and lessen the pressure up to point (c).
3 Before finishing the curve speed up and increase pressure to the left side of the line. Wait half a second at (d), lift the brush onto its tip and turn it to the right. Draw downwards leaning left to right.
4 At the end of the line release the energy in a big circular movement. Lean to the right of the line so that the brush hairs stay together at the end.

Linked circular movements

The repetitive links of the character の *no* (page 35), the essence of *kana*, help to master the big circular movements while varying the pressure of the brush and the side of the hairs where the pressure is applied.
1 Instead of releasing the energy at the end of the first character, continue the circular movement to draw the second character.
2 Repeat the same movements. Release the energy at the end.

Linked circular movements

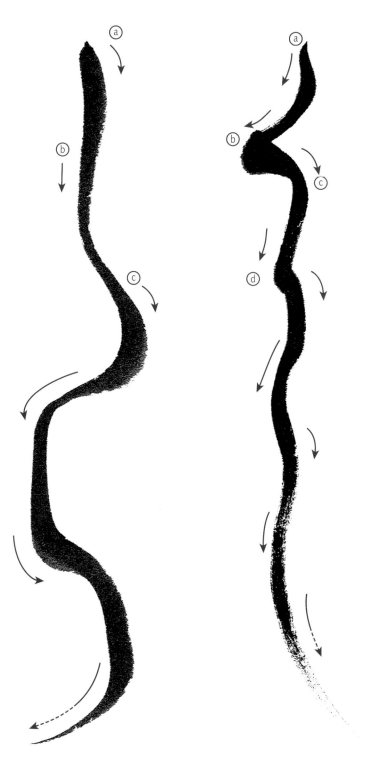

Serpentine line

*Winding line with
curves and bends*

45

Some words

はる *haru,* 'Spring'

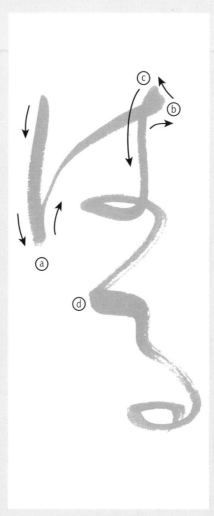

It is important to master the basic shape of は *ha* (page 34) and る *ru* (page 14) before moving on to the cursive styles.

1 Put the brush on the starting point and draw quickly down to point (a) and rest for half a second, then move on to point (b) whilst increasing the pressure.

2 Stop at (b) for half a second and lift the brush until only the tips of the brush hairs touch the paper and slide to point (c) with a small circular movement so that the brush hairs are in the direction of the next stroke.

3 Draw the next part of は *ha*. The energy released in the last movement must be regained in the rapid sequence up to (d), the first part of る *ru*. This must be drawn quickly whilst varying the pressure and the speed. Release the energy gently and lift the brush at the end of the movement.

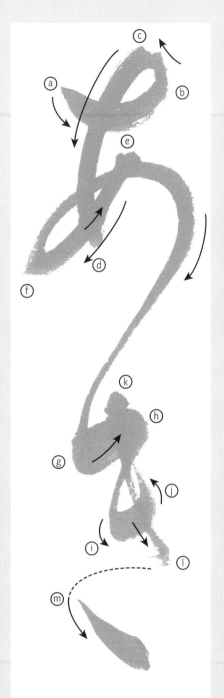

あき *aki*, 'Autumn'

This calligraphy uses the basic shape of **あ** *a* (page 37) and **き** *ki* (page 17).

1 Put the brush on the paper at (a) without too much pressure then do a quick stroke to point (b).

2 Lift the brush on its tip and slide it to (c) turning it a little to return the brush hairs to the direction of the movement. Wait half a second and do the arched stroke and lift the brush. Keep the brush point on the left side of the stroke.

3 Stop the movement at (d) and transfer the energy immediately to (e) and place the brush on its tip. Quickly draw the curve from (e) to (f).

4 At (f) slow and lift the brush. Do the big circular movement and change the pressure and the side of the brush. Lift the brush progressively at the end of **あ** *a*.

5 Regain the released energy in the first stroke of **き** *ki*. Draw quickly and firmly the line from (g) to (h) with a brief stop at each point. Release the energy at (i) and skim the brush to point (j).

6 Wait half a second at (k) and draw downwards to (l). This line is drawn only with the tip of the brush leaning to the left side. Stop at (l), lift the brush and release the energy which will be regained at (m) to end the movement.

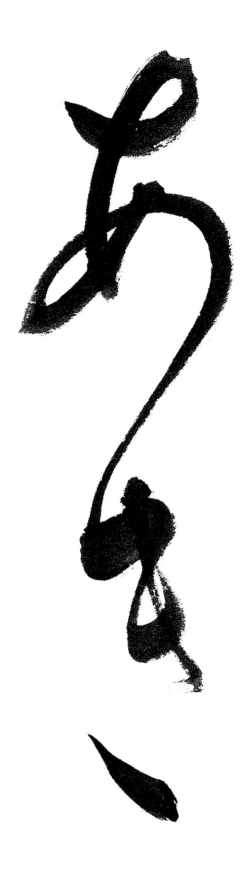

A stone pillow
Invites me
To follow the clouds

Poem (free *haiku*) by Taneda Santōka
種田山頭火 (1882-1940). A wandering
monk, Taneda Santōka gave himself body
and soul to the composition of *haiku*. He
invented rhythms different from the classical
5/7/5 syllables and did not always use a
seasonal word. (See page 57). Santoka
山頭火 and Ozaki Hōsai **尾崎放哉**
(1885-1926), who led a similar lifestyle,
are well known in the world of free *haiku*.

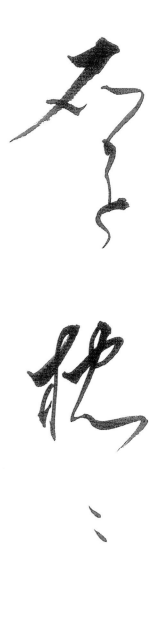

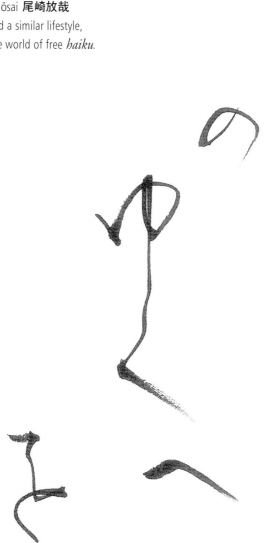

Slender brush calligraphy

Preparation

As in thick brush calligraphy, it is important to learn to form each *kana* separately with a slender brush before learning to write cursive *kana*. Even if the strokes are smaller, the movements of the body must remain big. The strokes must not become weak or rounded: on the contrary, small brush calligraphy would not come alive without movements that vary in speed and pressure, and the many changes in direction of the brush. The *kana* must be considered as a variety of *kanji*. Even with a small brush, it is necessary to draw with focused energy.

Holding the brush

There are three ways of holding a small brush. In each case the wrist should not be resting. The brush is usually held straight, not too tightly, and the body should be relaxed. The position of each finger on the handle is the same as for the thick brush (see page 30).

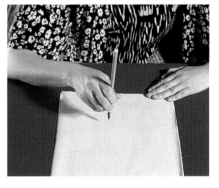

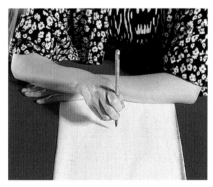

1 Hold the brush arm open with the elbow lifted. Put the fingers in the middle of the handle or a little lower. This position allows for big movements but is not suitable for writing very small characters.

2 Rest the elbow but keep the wrist free. Put the fingers at the bottom of the brush. This position is good for writing small characters. At an advanced level it is possible to hold the brush with only two fingers and the thumb allowing greater freedom of movement, useful for writing longer sequences of characters.

3 Put the left hand under the arm or elbow of the right hand (reverse for left handers). Put the fingers at the bottom of the handle. This position ensures a stable arm when writing small characters.

Basic movements

This double page shows some basic strokes which occur in seven Japanese characters. The brush used is approximately 0.6cm (⅟₄in) with 2.8cm (1⅛in) long brush hairs. It is made from a mixture of sable and tanuki. The exercise paper is of the *hanshi* format, 24.5 x 33cm (9⅝ x 13in).

し *shi*

The basic movement of し *shi* has been shown in the thick brush calligraphy section in the stroke from (a) to (c) in the serpentine line, page 44. The final movement ends after the brush has left the paper: the energy must be completely released.

つ *tsu*

The movement resembles the し *shi*, but in a horizontal direction. Release the energy gradually at the end whilst lifting the brush during the big circular movement.

と *to*

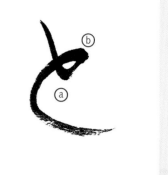

Place the brush gently and slide it to (a) whilst increasing the pressure. Lift the brush to its tip and release the energy which will be regained at (b). Wait half a second at (b), turn the brush to the right and make a big circular movement at the end whilst relaxing the pressure.

て *te*

Place the brush gently and slide immediately upwards to the right. At (a) wait half a second then turn the brush to the right. At the end release the energy and lift the brush.

ろ *ro*

The initial movement is as in て *te*, only shorter. At (a) and (b) turn the brush as in ね *ne* (page 36). The slanting line which joins these two points must be done quickly whilst leaning to the left. Continue the big circular movement at the end even after the brush has left the paper until all the energy has gone.

み *mi*

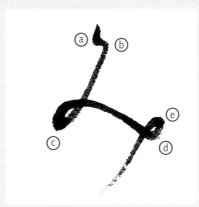

Place the tip of the brush and increase the pressure up to (a) then decrease it; this movement should take half a second. Skim over point (b) without stopping and quickly do the stroke to (c). Slow down, turn and lift the brush to draw to point (d). At (d) slow again, bring the brush to its point at (e) after turning the brush slightly. Stop for a second and draw downwards whilst releasing the energy. The pressure should be on the left side.

す *su*

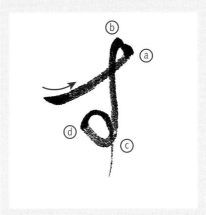

Draw the horizontal line to (a) quickly, wait a second and lift the brush to its point and slide it to (b) with a small circular movement. Wait a second on the brush tip at (b) and draw downwards leaning on the left side to (c). Lift the brush and release the energy up to (d) and regain the energy whilst drawing the last half of the oval. Continue drawing downwards and release all the energy in the circular movement.

Writing *kana*

なつ *natsu*, 'Summer'

ふゆ *fuyu*, 'Winter'

Some words

Here are some simple Japanese words to begin with. The aim is to learn to write words made up of several characters without interrupting the movement. Knowing how to read and pronounce the characters whilst drawing them will help to give the movement rhythm. The themes of nature and the passing of the seasons are essential to the Japanese way of life.

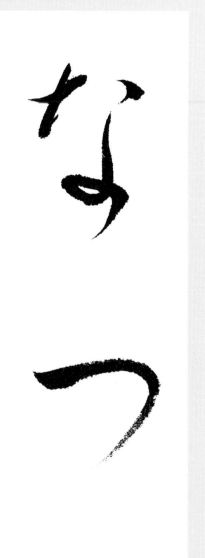

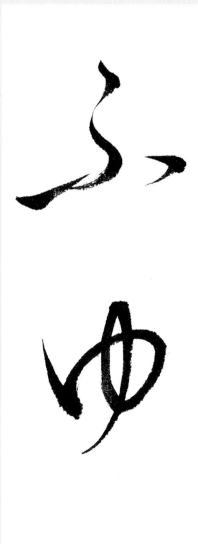

After soaking the brush hairs in the ink, wipe them well. The linking of strokes in な *na* must be smooth.

The strokes are all linked, even once the brush has left the paper. The rounded movements are not circles but a series of segments between which there must be a definite pause. Vary the speed.

さくら *sakura,* 'cherry tree'

もみじ *momiji,* 'maple, red Autumn leaves'

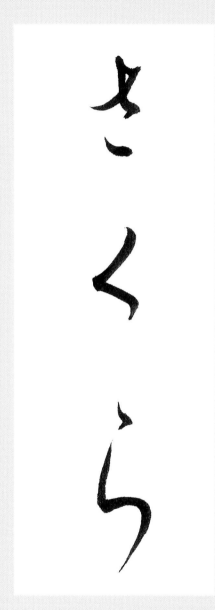

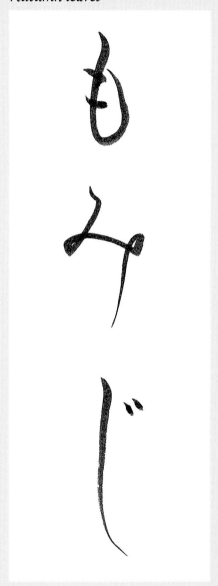

Turn the brush in the sequences especially at the end of the first stroke of さ *sa*. The three characters must be done in the same breath.

Lengthen the end of the character し *shi*, and add the two final small lines (left then right) to turn the character to じ *ji*.

なつまに

ふる、音や

竹の露

Haiku by Buson

いなづまに
こぼるる音や
竹の露

inazuma ni
koboruru oto ya
take no tsuyu

a flash of lightning
the sound of the dew
in the bamboos

Poem from the collection Perfume of the Moon.
Courtesy of Moundarren Editions.

3 kanji in kaisho

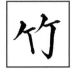 take, *'bamboo'*

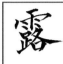 tsuyu, *'dew'*

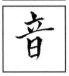 oto, *'noise'*

The term *waka* 和歌 applies to classical Japanese poetry as it has been practised since ancient times, as opposed to Chinese poetry *kanshi* 漢詩.
There are two types of *waka* poem:
▶ *chōka* 長歌 'long poem' made up of an indeterminate number of verses of 5 and 7 syllables, finishing with a verse of 7 syllables.
▶ *tanka* 短歌 'short poem' made up of 31 syllables in 5 verses of 5, 7, 5, 7 and 7 syllables. To give it rhythm, the *tanka* is broken down into two stanzas or *ku* 句 : 5-7-5 / 7-7.

In the 8th century it became common for a different poet to compose each of the two stanzas of a *tanka*. This form was called *renga* 連歌 or *haikai-renga* 俳諧連歌. Gradually the first stanza alone became known as *hokku* 発句, although it was still regarded as a 'poetic distraction'. In the 17th century Matsuo Bashō 松尾芭蕉 gave it his noble title. The term *haiku* 俳句 did not appear until the Meiji Era.

Haiku consists of 3 verses of 5, 7 and 5 syllables and contains a word of reference to a season, called *kigo* 季語 ('seasonal word'). In the poem shown opposite the seasonal word is *inazuma* いなづま ('flash of lightning') which represents the Autumn.

This piece of calligraphy is based on a *haiku* poem by Yosa Buson 与謝蕪村 (1716-1783) on *kōzo* paper in the style representing the first stage of learning cursive slender brush calligraphy. The three *kanji* that have been mixed with *kana* are 音 *oto* ('noise'), 竹 *take* ('bamboo') and 露 *tsuyu* ('dew'). The use of classical calligraphy does not add the two little lines to the characters つ *tsu* and ほ *ho* to make them into *zu* and *bo*, even if they have to be read thus. In modern Japanese, 'flash of lightning' is written いなずま, but in classical calligraphy the original written form is kept: *inazuma* いなづま. The word comes from *ine* 稲 and *tsuma* 夫 and means literally 'the wife

of rice'. In fact, the ancient belief was that lightning often came during the rice season and enriched the harvest.

The small slightly curved line after the character る *ru* is used in classical calligraphy to repeat the preceding syllable: here it should read: *koboruru*, meaning 'overflowing, falling'.

Cursive *kana* writing (renmen-tai)

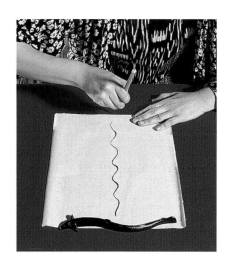

Cursive calligraphy written with a slender brush is a typically Japanese genre. It can be done using various types of brush and paper. As for thick brush calligraphy the basic exercises teach how to vary and give rhythm to the strokes.

To begin with it is best to use the same brush as for non-cursive writing. The exercise paper can eventually be replaced by *ganpi* paper. The brush is held as shown on page 51. The wrist remains free and the body flexible to allow for big movements.

The basic movements

Long vertical line
Place the brush and draw downwards quickly without too much pressure. Stay calm. Lift the brush slowly towards the end.

Wavy line
Lift the brush whilst turning and alternate the application of pressure from side to side. The whole movement is done quickly.

Zigzags
At each angle lift the brush slightly and reposition it half a second later to change the side and quickly draw the line to the next angle. Each change of direction must be clearly marked.

Line with folds
These are the links of the character リ *ri*, in the normal and inverse direction. At (a) stop and lift the brush to lift and curve the line. Descend rapidly to (b) then repeat the movement from (a) but in the opposite direction.

Linked circular movements
These are the links of the character の *no* : the exercise is identical to the third basic stroke of thick brush cursive calligraphy (page 45). It is important to be flexible and to vary the pressure and the side to which it is applied.

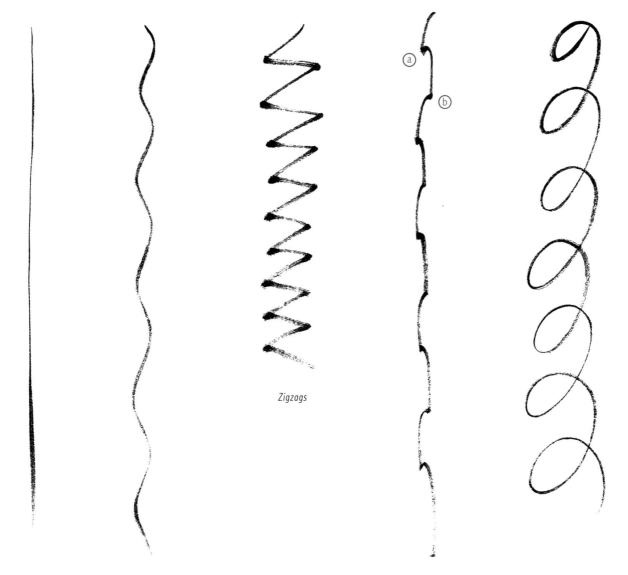

Zigzags

Long vertical line Wavy line Line with folds Linked circular movements

うめ *ume*, 'plum tree'　　　ゆき *yuki*, 'snow'

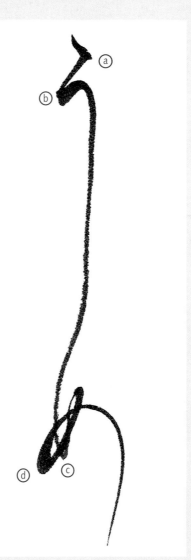

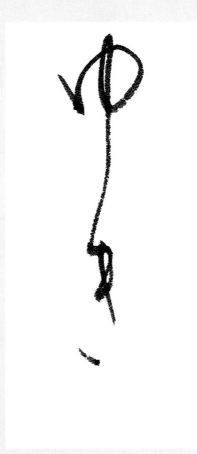

Some words

The linking of some characters requires enormous concentration. The relationship between the writing and the blank space around it is crucial. Before commencing it is important to form a mental image of the word in its entirety as it will appear on the page. By keeping the wrist flexible and varying the pressure and speed it is possible to draw a line that will flow like a piece of music.

Link the two characters almost as in うめ *ume*.

At (a) and (b) stop and change the brush direction. The final line of う *u* is long and must be done without applying too much pressure. The linking of the first line of め *me* is done across a slight curve to the left. At (c) and (d) wait half a second and lift the brush to turn it easily.

The movements of め *me* are a slightly simplified from the basic shape (page 17) giving a more rounded form at the end from which the energy must be released gently.

ことり *kotori*, 'small bird'

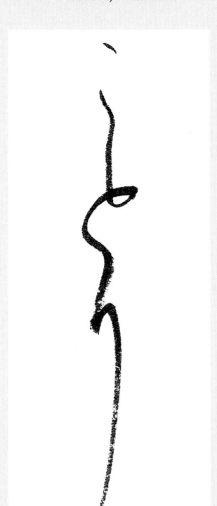

The linking of と *to* and り *ri* is done inside the first line of り *ri*. Sometimes light and sometimes energetic, the variations in the stroke give life to the word.

こがらし *kogarashi*, 'Winter wind, wind that makes trees perish'

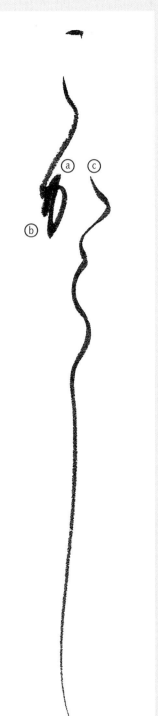

After linking こ *ko* and か *ka*, stop at the beginning of the か *ka* and change the direction of the brush. The left side of か *ka* must be drawn quickly, waiting half a second at (a). At (b), stop and release the energy which will be regained at (c). Draw the last part of the か *ka* with nuances. In accordance with its use in classical calligraphy, the last little lines are not added in the か *ka*, but this last character must nevertheless be read as が *ga*. The ら *ra* and the し *shi* must be drawn and linked smoothly, keeping a free arm.

しづかさや岩にしみ入るせみのこゑ

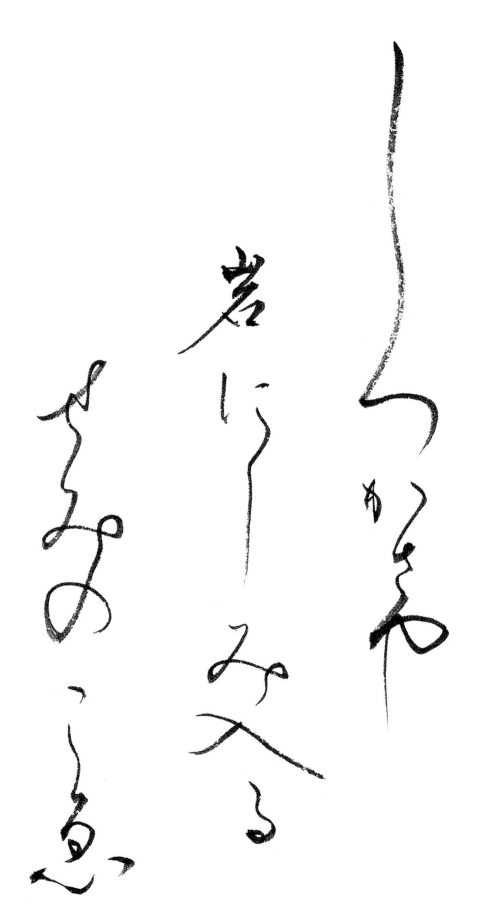

Haiku by Bashō

しづかさや
岩にしみ入る
せみのこゑ

*shizukasa ya
iwa ni shimiiru
semi no koe*

*silence
the song of the cicada
penetrates the rocks*

Poem from the collection In Kyoto
dreaming of Kyoto. *Courtesy of
Moundarren Editions.*

Bashō who was called *haisei* 枕聖 (the
Patron Saint of *haiku*), (1644-1694)
brought *haikai* 俳諧 from a simple
passtime to whole poetic art. Influenced by
Chinese poetry and Zen philosophy, Bashō
lived the life of an ascetic wanderer and
strove to communicate the beauty of
nature in a pure, simple form. Towards
the end of his life he sought above all a
certain 'lightness' and beyond this
'lightness' the essence of all things. He had
many followers.

As shown on page 57, a *haiku* consists of
5, 7 and 5 syllables. The calligraphy shown
opposite is made up of three lines, each
constituting a verse. This layout is not
obligatory: *haiku* can be written in a single
line or several lines.

The two *kanji* 岩 *iwa* (rock) and 入（る）
i (ru) (penetrate) are written in cursive style
calligraphy.

2 kanji *in* kaisho

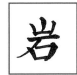

iwa, *'rock'*

i (ru), *'penetrate'*

In modern Japanese 'tranquillity' is written
しずかさ , but here the ancient written
form しづかさ is used (omitting the last
two little lines of づ). The character ゑ *e* –
pronounced *we* – has fallen into disuse, and
been replaced by え *e*.

Before starting the calligraphy it is
important to imagine the scene evoked by
the *haiku*, and to visualise it while drawing
the characters that should be learnt by
heart. Even once the brush has left the
paper you need to keep in mind that the
characters are linked.

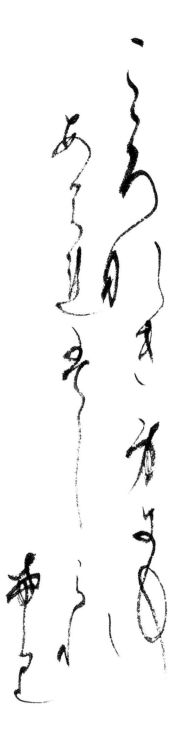
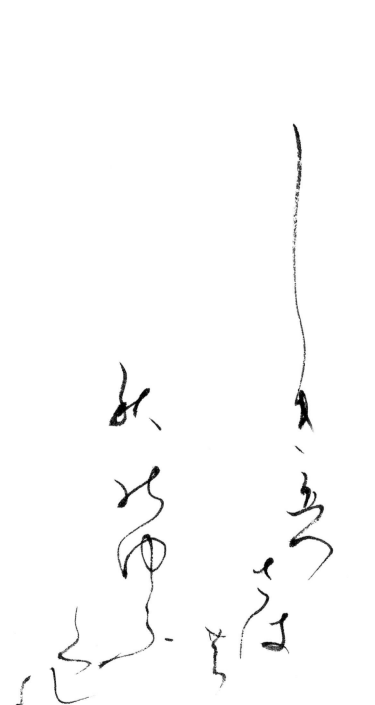

Tanka by Saigyō

こころなき
　　那

身にも　あわれは
　尒　　　者連盤

しられけり
　　希里

しぎ立つ　さわの
　　　　（は）農

秋の　ゆうぐれ
　能　　（ふ）

kokoro naki
mi ni mo aware wa
shirare keri
shigi tatsu sawa no
aki no yūgure

even somebody
with a free heart
feels sadness
when a woodcock flies from the marsh
in the twilight of Autumn

Poem from the collection Poems from my Mountain Hut. *Courtesy of Moundarren Editions.*

aki, *'Autumn' in* kaisho

mi, *'body, person' in* kaisho

aki, *in* sōsho

mi, *in* sōsho

Born into a family of Samurai, Saigyō 西行 (1118-1190) became a Buddhist at the age of 23 and was well known as a poet of *waka*. Many of his poems were written whilst on pilgrimages across Japan. Searching for harmony between art and nature in a free spirit, he had an enormous influence over later poets especially Bashō.

The *tanka* shown opposite is part of the *sanseki no uta* 三夕の歌 (three evening tankas), three poems by different authors. It is considered one of the best of its genre and is found in the *Shin kokin waka shū* 新古今和歌集 (new collection of ancient and modern *waka*), an imperial anthology compiled between 1201 and 1205.

The brush used was a thick *mensō-hitsu* 面相筆, 0.4cm (³/₁₆in) in diameter, with 3cm (1/in) long brush hairs of weasel hair, thin with long and pointed hairs. Its use requires a high level of expertise.

Typically Japanese, this style of calligraphy is called *chirashi-gaki* 散らし書き (scattered writing). It is written without lining up the characters, but plays on the rapport between the empty spaces and he strokes.

For this, several *kana* are used. In the printed version of this poem under each of the *kana* (in modern form) the *kanji* from whence it came is shown. The two *kana* わ *wa* and う *u* are also written in the old style calligraphy; は and ふ. しき is read as *shigi* (woodcock) and not *shiki*. The three *kanji* 身 *mi* (body, person), 立 (つ) *ta* (*tsu*) (lift, fly away) and 秋 *aki* (Autumn) are written in cursive style calligraphy: the 身 and 秋 are in *sōsho* 草書 ('grass' style), a style very different from the block *kaisho* 楷書 style.

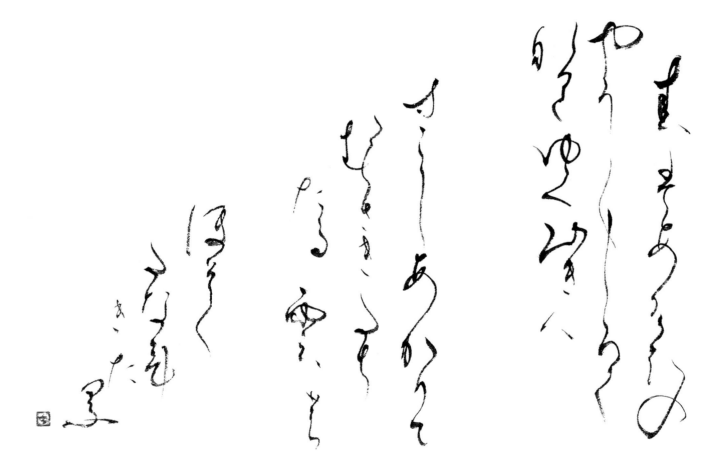

Excerpts from *Notes from the Pillow*

春はあけぼの　やうやうしろくなりゆく　山ぎは
　盤　介本　　　　　　　久那里　　　　　　八

すこしあかりて　むらさきだちたる　雲のほそく　たなびきたる
寸　　　　　　　　多　　　　農　久　多　飛　累

Haru wa akebono
Yōyō shiroku nariyuku yamagiwa
sukoshi akarite murasaki dachitaru
kumo no hosoku tanabikitaru

In the Spring, I prefer the dawn
The mountain peaks slowly become
Distinct and light up faintly
Mauve and purple clouds lie
In slender trails

Gallimard/Unesco Editions.

The *Makura no sōshi* 枕草子 (notes from the pillow) is made up of approximately 300 chapters (in the Japanese version), the shortest of which are made up of just one line. Written in poetic style, this book was the first of the literary genre *zuihitsu* 随筆 (on the brush line).

Sei Shōnagon 清少納言 (966 ?-1024 ?), a lady-in-waiting to an Empress, was born into a family of famous poets. Having an in-depth knowledge of Chinese literature, she wrote many intellectual works and *tanka* poems.

Sei Shōnagon and Murasaki Shikibu 紫式部 also a lady of the court and author of *Genji Monogatari* 源氏物語 (The Tale of Genji), are pillars of Japanese literature of the Heian Era.

The work shown opposite was written with the same brush *mensō-hitsu* 面相筆 as the *tanka* of Saigyō shown on page 64, although here the thickness of the lines is more varied. Calligraphy must remain in harmony with the original text. The strokes must keep their poetic appearance and become poetry themselves.

In the printed character version, under each *kana* (in modern form) is the *kanji* from which the ancient *kana* in the calligraphy came. やうやう *ya u ya u* is read *yōyō* and is now written ようよう. やうやう corresponds to an ancient usage which conforms to the 歴史的仮名遣い *rekishiteki kana-zukai* ('historical use of *kana*'). 山ぎは *yamagiha* is read *yamagiwa* and, for the same reason, is now written 山ぎわ. The size, shape and position of the seal must be chosen as part of the overall work.

Classical and contemporary works

Classical style calligraphy such as cursive slender brush *kana* or Chinese texts in large format are still written and appreciated. Contemporary Japanese calligraphy allows experimentation with new styles, forms and ways of writing expressed in original works.

▶ Masuichi Tōyō 増市東陽 (1906-1997), *tanka* poem by Ki no tomonori 紀友則. (*Kokin waka-shū* 古今和歌集). Poem no. 337. Private collection.

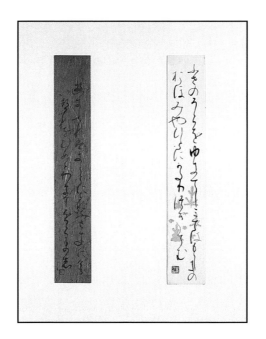

◀ Suzuki Kakuyō 鈴木鶴陽, (born 1923), *tanka* poem from Tanabe no Hubito Sakimaro 田辺史福麿 (Man.yō-shū 萬葉集). Poem no 4040. Private collection.

▶ Masuichi Tōyō 増市東陽 (1906-1997), extract from a Chinese Buddhist document from the 7th century, Shūji shōgyō jo 集字聖教序. Private collection.

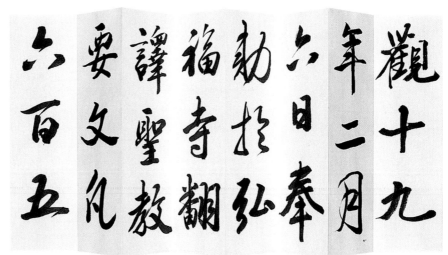

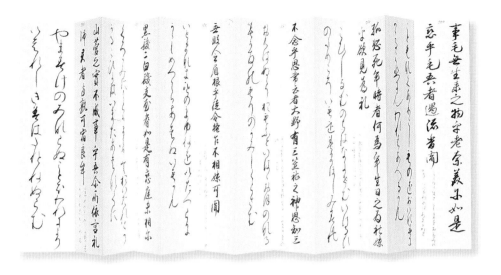

◀ Masuichi Tōyō 増市東陽 (1906-1997), extract from *Man.yō-shō* 萬葉集. Each poem is written in *hentai-gana* 変体仮名 and in *sō-gana* 草仮名. Private collection.

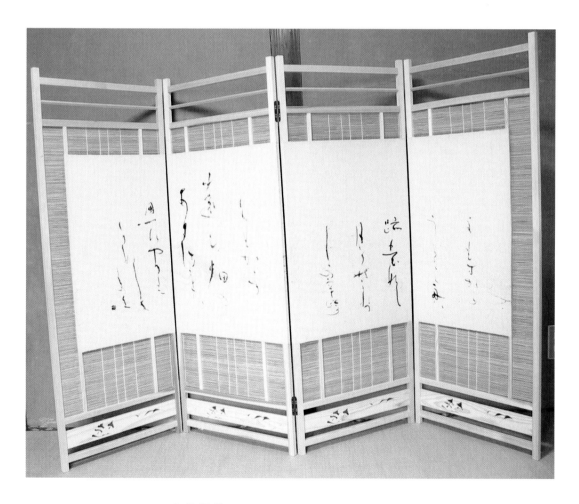

▲ Ōshima Sanpō 大嶋三峰 (born 1944), two poems from *Shin kokin waka-shū* 新古今和歌集 (poems no. 1505 and no. 1560). Private collection.

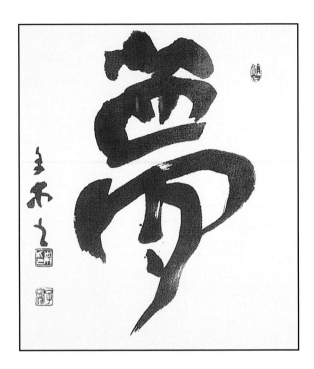

◀ Sumiyama Nanboku
炭山南木 (1895-1979),
Yume 夢 (Dream).
Private collection.

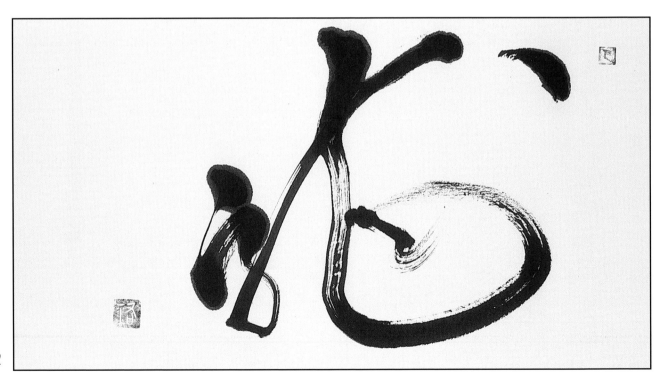

▲ *Yuuko Suzuki* (Suzuki Suigyoku 鈴木翠玉), *Ryū* 龍 (Dragon). Private collection.

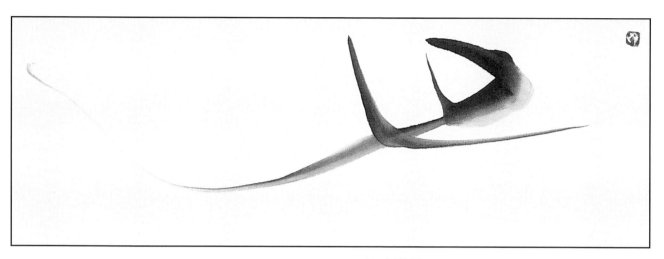

▲ Yuuko Suzuki (Suzuki Suigyoku 鈴木翠玉),
Ko 子 (Child). Private collection.

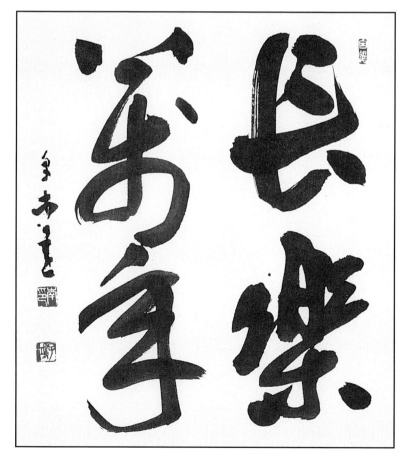

◀ Sumiyama Nanboku
炭山 南木 (1895-1979),
Chōraku mannen 長楽萬年
(Immortal joy).
Private collection.

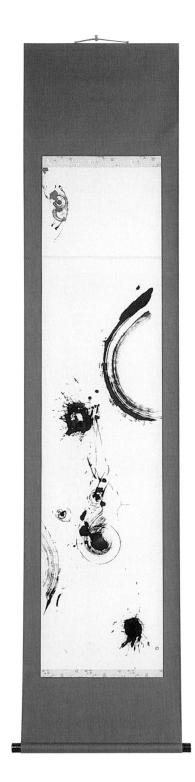

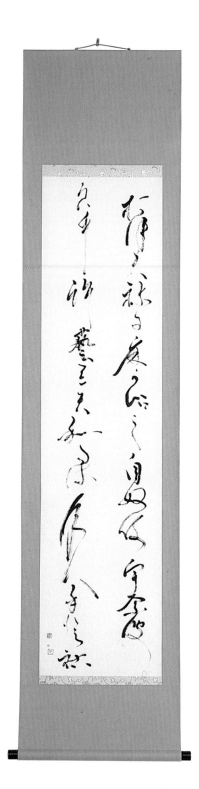

▲ Yuuko Suzuki (Suzuki Suigyoku 鈴木翠玉), ink. Private collection.

▲ Yuuko Suzuki (Suzuki Suigyoku 鈴 木 翠 玉), *tanka* poem from *Kakinomoto no Hitomaro* 柿本人麻呂 (7th and 8th centuries, Japan). *Man.yō-shū* 萬 葉 集, poem no. 3611. Private collection.

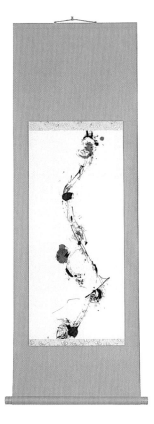

◀ Yuuko Suzuki (Suzuki Suigyoku 鈴木翠玉), ink. Private collection.

▼ Yuuko Suzuki (Suzuki Suigyoku 鈴木翠玉), ink installation. Private collection.

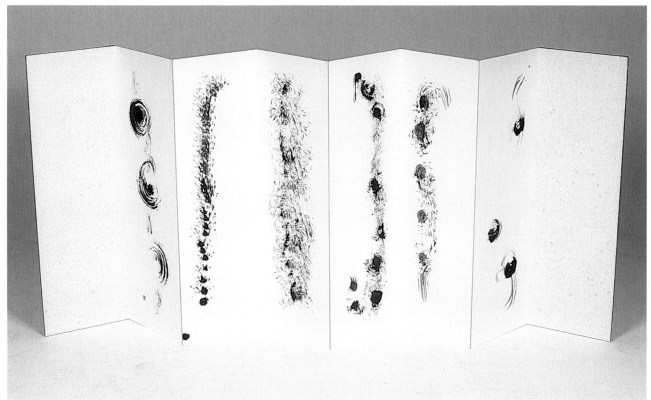

Backing techniques

Backing (in Japanese, *urauchi* 裏打ち) involves the glueing of several layers of thin paper, usually *kōzo*. onto the back of a work of painting or calligraphy. The process flattens and strengthens the original paper which, due to the ink, is no longer perfectly flat. This is a vital preparation for traditional framing *hyōsō* 表装 (see opposite) or for mounting under glass. It is recommended for all works, to keep them in good condition. Before backing a work of calligraphy, it should be left to dry for at least a week. The photographs show the basic backing technique. For larger works several more complex stages are involved.

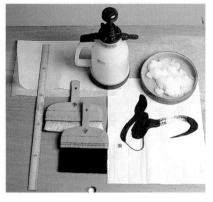

1 Materials used: a water spray, rice starch glue, backing paper, glue brush, backing brush, a flat bamboo stick.

2 Spray the back of the work evenly. Leave the paper to 'expand' for a few minutes.

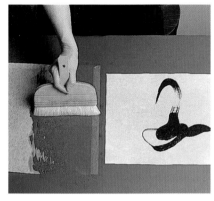

3 Spread the glue on to the backing paper with a brush of goat hair.

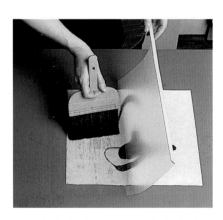

4 Apply the backing paper to the back of the work using a vegetable brush. The other hand holds the paper suspended from the bamboo stick.

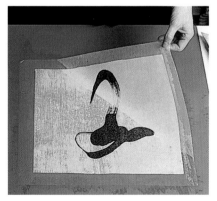

5 The two papers are now attached; the backing paper is bigger than the original work.

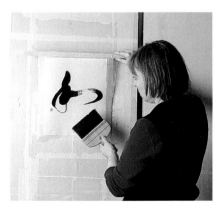

6 Lift the whole thing and hang it vertically. Leave to dry for 24 hours. The papers will stretch and, once dried, be totally flat.

Kakejiku mounting

Originating in China, *kakejiku* 掛軸 or *kakemono* 掛物 is the most widely used mounting method for calligraphy and painting. It comes in a roll which is opened to hang on the wall. The roll is held at the top by a fine semi-cylindrical stick. Another stick, bigger and cylindrical, gives weight at the bottom. Their ends are covered by a piece of ivory, horn, red sandalwood, lacquer, pottery or crystal. The choice of colour and design is important as it must be in harmony with the work. *Kakejiku* mounting by hand is a complex task and is left to specialists.

Shown are some examples of *kakejiku*. The first three were designed for religious works. The work is put inside two fabric frames. The fourth is called *maru-byōsō* 丸表装 or *maru-byōgu* 丸表具, (full mounting). It is the simplest style with the work inside a single fabric frame and decorated with two horizontal ribbons *ichimonji* 一文字. The final style is called *daibari-byōsō* 台帳 表装 or *dai-byōgu* 台表具 (mounting on a stand). It is used for smaller works. The work is put on a stand before framing. There are other ways of showing work: horizontal roll, accordion book, folding screen for example. These styles of framing are called *hyōsō*.

1 Full mounting with two horizontal and two vertical ribbons surrounding the work, and with two vertical ribbons above.
2 Simplified mounting, without vertical ribbons surrounding the work.

3 Mounting without surrounding ribbons. Only two vertical ribbons above.
4 Complete mount. The work is placed in a single frame. No ribbons.
5 Mounting on a stand.

Tables showing *hiragana* and *katakana*

The 'table of 50 sounds' shows all the basic sounds of the Japanese language. These can be shown in both *hiragana* and *katakana* syllabaries. In fact the table has only 47 syllabary sounds plus the ん (*hiragana*) or ン (*katakana*) '*n*'. Some sounds have disappeared from modern Japanese and in tables used for elementary teaching they have been replaced by い -イ *i*, う -ウ *u* or え -エ *e*. In addition to these 47 basic syllables, there are 61 other syllables born of the need to transcribe Chinese words.
The tables should be read vertically from left to right.

Hiragana

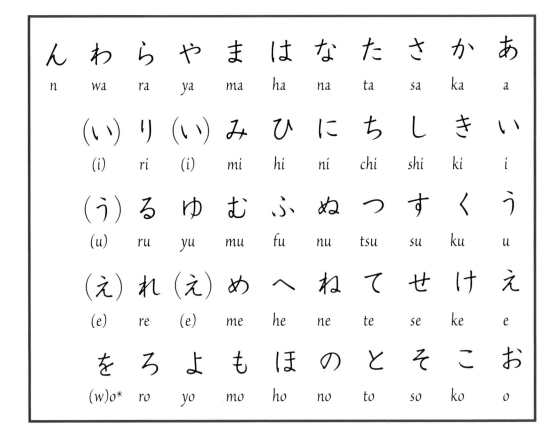

ん	わ	ら	や	ま	は	な	た	さ	か	あ
n	wa	ra	ya	ma	ha	na	ta	sa	ka	a
	(い)	り	(い)	み	ひ	に	ち	し	き	い
	(i)	ri	(i)	mi	hi	ni	chi	shi	ki	i
	(う)	る	ゆ	む	ふ	ぬ	つ	す	く	う
	(u)	ru	yu	mu	fu	nu	tsu	su	ku	u
	(え)	れ	(え)	め	へ	ね	て	せ	け	え
	(e)	re	(e)	me	he	ne	te	se	ke	e
	を	ろ	よ	も	ほ	の	と	そ	こ	お
	(w)o*	ro	yo	mo	ho	no	to	so	ko	o

*Today, を *o* is used only as a particle or in proper nouns.

Katakana

ン	ワ	ラ	ヤ	マ	ハ	ナ	タ	サ	カ	ア
n	wa	ra	ya	ma	ha	na	ta	sa	ka	a
	リ		ミ	ヒ	ニ	チ	シ	キ	イ	(イ)
	ri		mi	hi	ni	chi	shi	ki	i	(i)

	(イ)	リ	(イ)	ミ	ヒ	ニ	チ	シ	キ	イ
	(i)	ri	(i)	mi	hi	ni	chi	shi	ki	i
	(ウ)	ル	ユ	ム	フ	ヌ	ツ	ス	ク	ウ
	(u)	ru	yu	mu	fu	nu	tsu	su	ku	u
	(エ)	レ	(エ)	メ	ヘ	ネ	テ	セ	ケ	エ
	(e)	re	(e)	me	he	ne	te	se	ke	e
	ヲ	ロ	ヨ	モ	ホ	ノ	ト	ソ	コ	オ
	(w)o*	ro	yo	mo	ho	no	to	so	ko	o

*Today, ヲ *o* is used only as a particle or in proper nouns.

Glossary

Gyōsho (*xingshu* in Chinese) 行書 : 'running style'* of *kanji* calligraphy.

Haiku 俳句 : genre of classical Japanese poetry, made up of three verses of 5, 7 and 5 syllables (it is a derivative of *tanka*), and containing a *kigo* 季語 or a 'seasonal word'.

Hanshi 半紙 : Chinese and Japanese paper, approx. 24.5 x 33cm (9⅝ x 13in).

Hentai-gana 変体仮名 (varied *kana*): Japanese *kana* also called *onna-de* (women's writing), which comes from an elegant simplified calligraphy called *sō-gana*.

Hiragana 平仮名 (easy *kana*) : Japanese characters, which come from an artistic simplification of *hentai-gana*. Since the Meiji Era there are 47 *hiragana* and 47 *katakana* shown in the 'table of 50 sounds'. Today, *hiragana* is used principally to denote verb and adjective endings and for grammatical particles.

Inochi-ge 命毛 ('hairs of life'): the 2 or 3 longest hairs in the middle of the plume of a Japanese calligraphy brush. They are for the lines of *kana*, and of the thinner *kanji*.

Kaisho 楷書 (*kaishu* in Chinese): 'block style' of *kanji* calligraphy.

Kakejiku 掛軸 or *kakemono* 掛物 : vertical roll, the most widely used traditional framing style *hyōsō* 表装, which is unrolled and hung on a wall.

Kana 仮名 (provisional writing): Japanese characters. They are all purely phonetic. Each one comes from *kanji*. In addition to *hiragana* and *katakana* (the two modern syllabaries), the *man.yō-gana*, *sō-gana* and *hentai-gana* are still used in calligraphy.

Kana renmen-tai 仮名連綿体 : Joined up *kana* calligraphy.

Kanbun 漢文 : literally 'classical Chinese' also called *mana* (real written language). It was an intermediate written language based on Chinese, used officially in Japan until the reforms of the Meiji Era.

Kanji 漢字 : Chinese characters, ideograms.

Kanshi 漢詩 : Chinese poetry.

Katakana 片仮名 one of two Japanese syllabaries shown in the 'table of 50 sounds'. These Japanese symbols formed from the phonetic of *kanji* are used today to write foreign words and onomatopoeia, or to replace complex *kanji*.

Kimyaku 気脈 (joining up of *ki* 気): the *ki* represents breath, energy, soul, spirit, humour. The joining up of *ki* is the most important element of calligraphy.

Man.yō-gana 萬 葉 仮 名 (*kana* of the *Man.yō-shū*) : also called *ma-gana* or *onoko-de*. These were the first Japanese characters based on *kanji* in the *kaisho* style. At that time the Japanese used Chinese characters phonetically, disregarding the meaning and keeping only the sound.

Mana 真 名 (real written language): see *kanbun*.

Onna-de 女 手 : see *Hentai-gana*.

Onoko-de 男 手 : see *Man.yō-gana*.

Rakkan 落 款 : abbreviation of *Rakusei-kanshi* 落 成 款 識 (engraved signature certifying the completion of a piece of work).

Reisho 隷 書 (*lishu* in Chinese): style of 'scribes' of *kanji* calligraphy.

Sō-gana 草 仮 名 : Ancient Japanese characters used to complete the *man.yō-gana* which was at the origin of *kanji* in the *kaisho* style. The *sō-gana*, also phonetic writing, are in the *gyōsho* and *sōsho* style, which helps in the phonetic transcription of Japanese.

Sōsho 草 書 (*caoshu* in Chinese) : 'grass style'* of *kanji* calligraphy.

Tanka 短 歌 (short poem): one of the most common forms of *waka*, classical Japanese calligraphy. Made up of 31 syllables in five verses of 5, 7, 5, 7 and 7 syllables.

Tenkoku 篆 刻 : The art of seal engraving.

Tensho 篆 書 (*zhuanshu* in Chinese) : 'seal style' of *kanji* calligraphy.

Urauchi 裏 打 ち : backing.

Waka 和 歌 : Classical Japanese poetry which has been practised for many years, of which one of the most popular forms is *tanka*.

Washi 和 紙 : Traditional Japanese paper made by the original method *nagashi-zuki* 流 し 漉 き 'agitation method'.

* Sometimes the *gyōsho* style of writing is known as semi-cursive and the *sōsho* style as cursive. Actually they are both cursive styles and 'running' and 'grass' correspond to the literal translation of the original Japanese.

Chronology

Japan

c. 12 000 BC c. 300 BC	縄文時代 *Jōmon jidai* Jōmon Civilisation
c. 300 BC- c. 300 AD	弥生時代 *Yayoi jidai* Yayoi Civilisation
IIIrd au VIth century	古墳時代 *Kofun jidai* Civilisation of ancient burial mounds
VIth - VIIth century	飛鳥時代 *Asuka jidai* Asuka Period
710 - 784 (or 794)	奈良時代 *Nara jidai* Nara Period
794 - 1185 (or 1192)	平安時代 *Heian jidai* Heian Period
1192 - 1333	鎌倉時代 *Kamakura jidai* Kamakura Period
1333 - 1336	建武の親政 *Kenmu no shinsei* Restoration of Kenmu
1336 - 1392	南北朝時代 *Nanbokuchō jidai* Civil war between the Imperial courts of the south and the north
1392 - 1573	室町時代 *Muromachi jidai* Muromachi Period
1573 - 1603	安土・桃山時代 Azuchi Momoyama jidai Azuchi Momoyama Period
1603 - 1868	江戸時代 *Edo jidai* Edo Period
1868 - 1912	明治時代 *Meiji jidai* Meiji Era
1912 - 1926	大正時代 *Taishō jidai* Taishō Era
1926 - 1989	昭和時代 *Shōwa jidai* Shōwa Era
1989 onwards	平成時代 *Heisei jidai* Heisei Era

China

Before 1700 BC	彩陶文化／黒陶文化 Periods of red and black pottery
c. 1700 - c. 1100 BC	殷 *Yin or* 商 *Shang Dynasties*
c. 1100 – 256 BC	周 *Zhou Dynasty*
221 - 207 BC	秦 *Qin Dynasty*
206 BC – 220 AD	漢 *Han Dynasty*
220 - 589	三国時代 *The Three Kingdoms* and 六代 *the Six Dynasties*
581 - 617	随 *Sui Dynasty*
618 - 907	唐 *Tang Dynasty*
907 - 960	五代 *The five Dynasties*
960 - 1279	宋 *Song Dynasty*
1271 - 1367	元 *Yuan Dynasty*
1368 - 1644	明 *Ming Dynasty*
1644 - 1911	清 *Quing Dynasty*
1912 -	中華民国 *The Democratic Republic of China*
1949 -	中華人民共和国 People's Republic of China